About this book

Turn your devices to silent. Limit distractions. Allow yourself to relax and be drawn into the peace that colouring brings.

Experimentation is what it's about! There is no right or wrong way to colour. You will develop your own way along your colouring journey. Use the test page and play with your colours.

This book works best with coloured pencils or markers. The images are printed on one side of the page only. Using wet mediums could bleed through to the image on the next page. Slip a piece of card behind the image you're working on to prevent this.

This is your collection of images so don't be sacred to dismantle this book. You may wish to cut out finished pages and frame them.

Top tips

I would recommend Faber Castell Polychromos pencils or Prismacolor Premier Soft Core pencils. They are perfect for the job, but of course you can use other coloured pencils, markers, watercolour pencils, chalk pastels, gel pens or crayons on grayscale pages. They each produce their own interesting effect.

If you are colouring with oil-based pencils, dip the point of the pencil into Vaseline (petroleum jelly). This will dramatically aid seamlessly blending shades together – it works very well.

Place a piece of card behind the image you're working on to protect the image underneath from pencil pressure or bleed through.

Test page

You can write the name of the colour or the type of pencil used in the space below the square, so you can remember which are your favourite colours...

Test page

You can write the name of the colour or the type of pencil used in the space below the square, so you can remember which are your favourite colours...

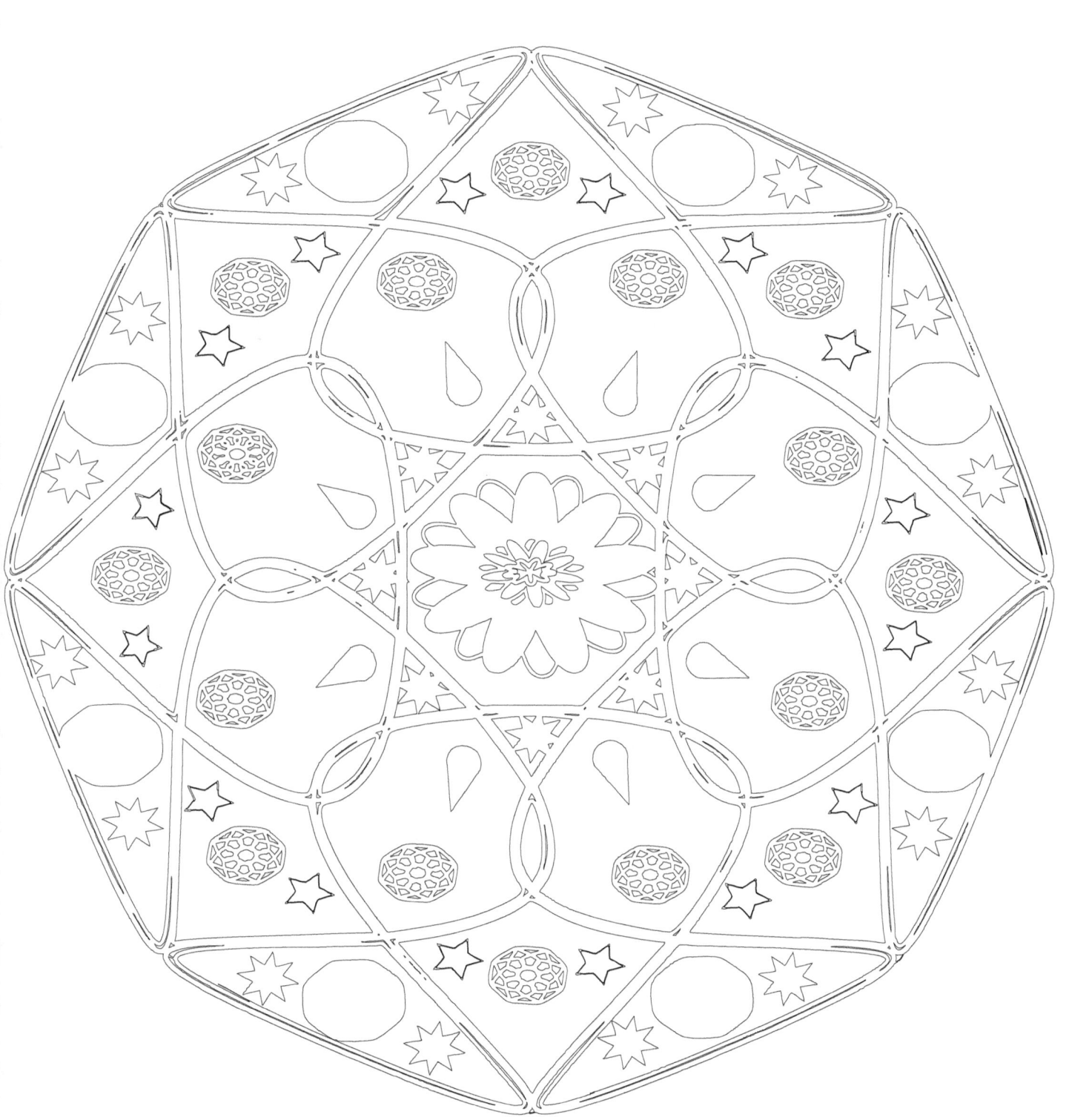

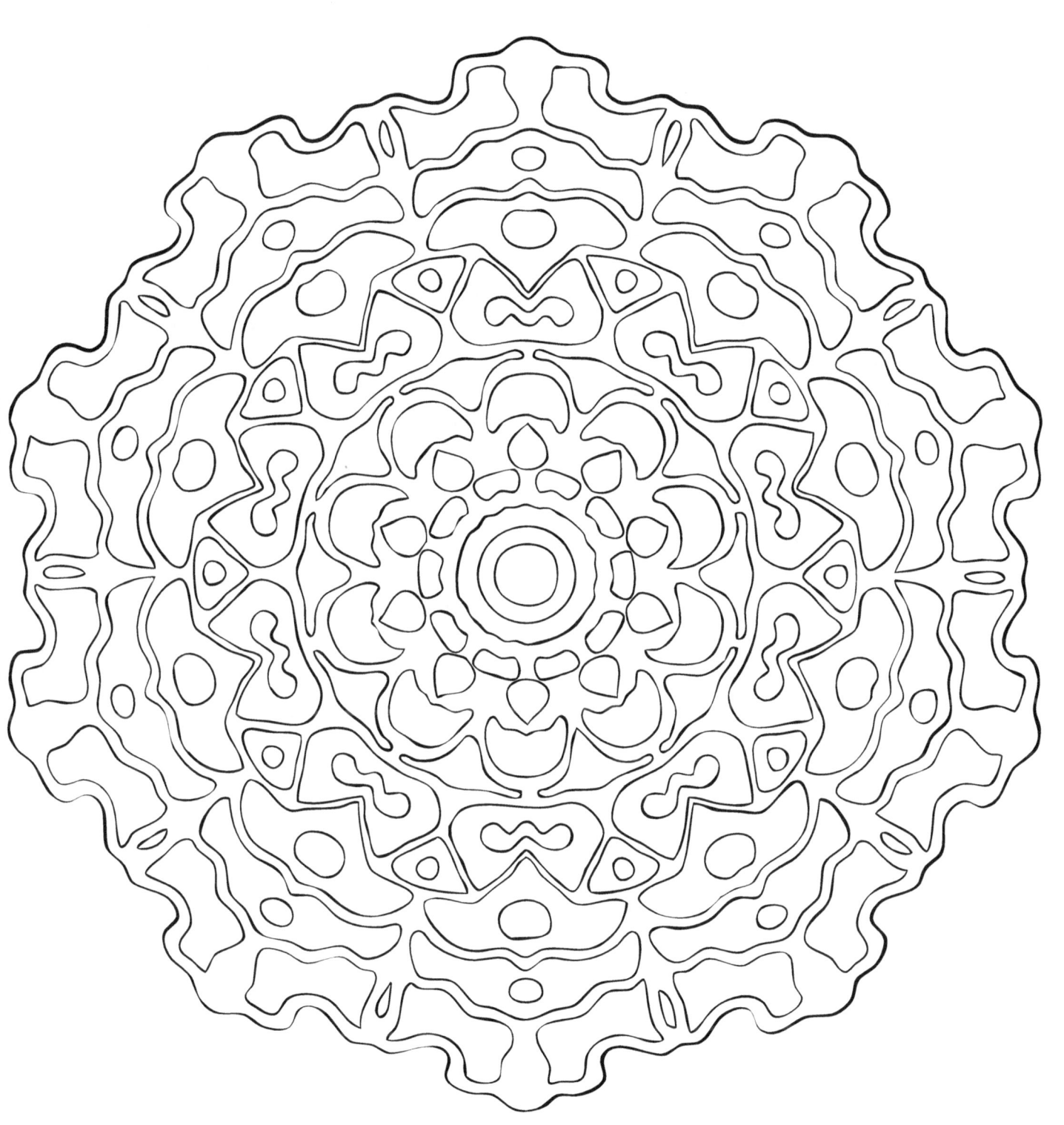

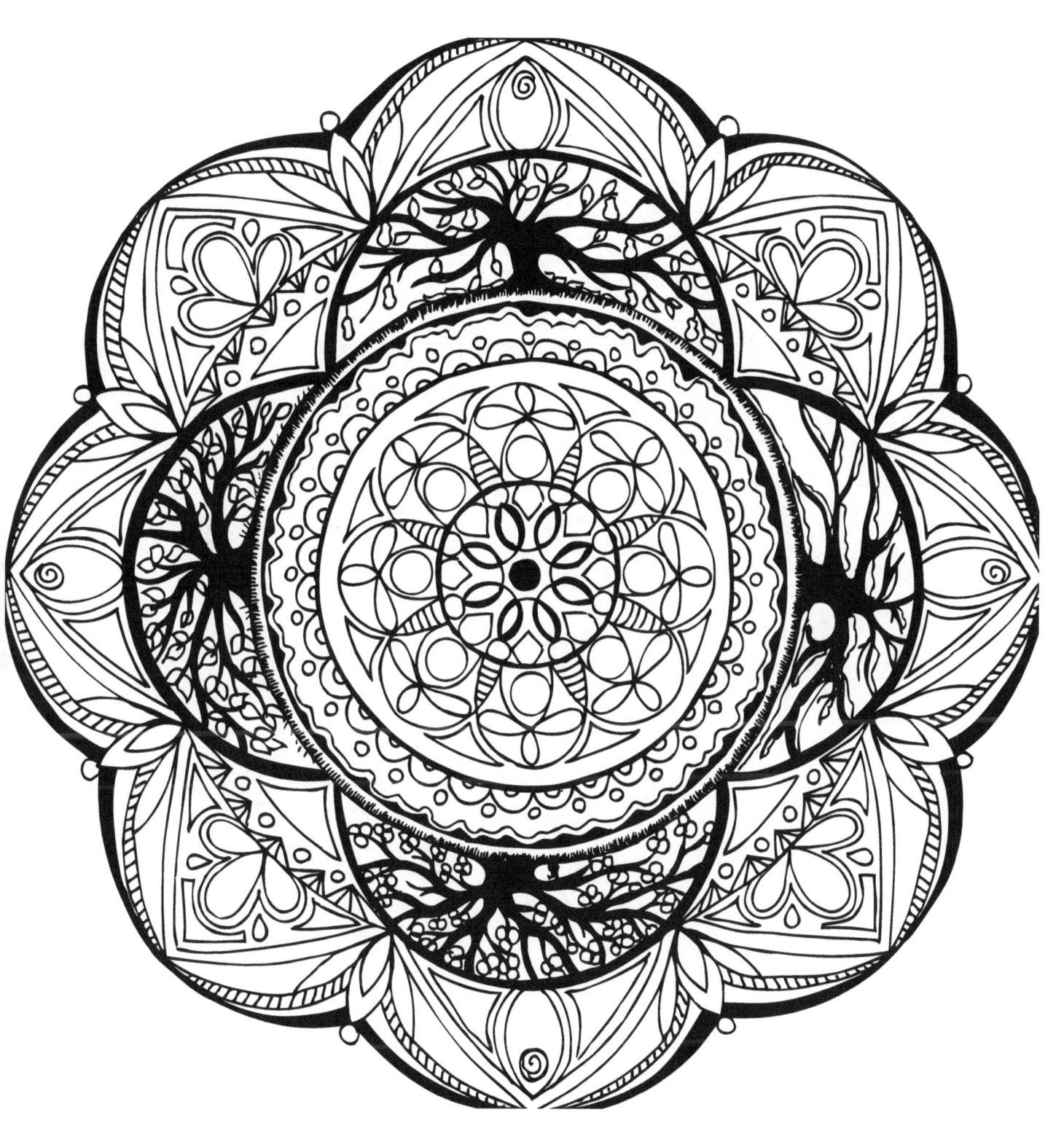

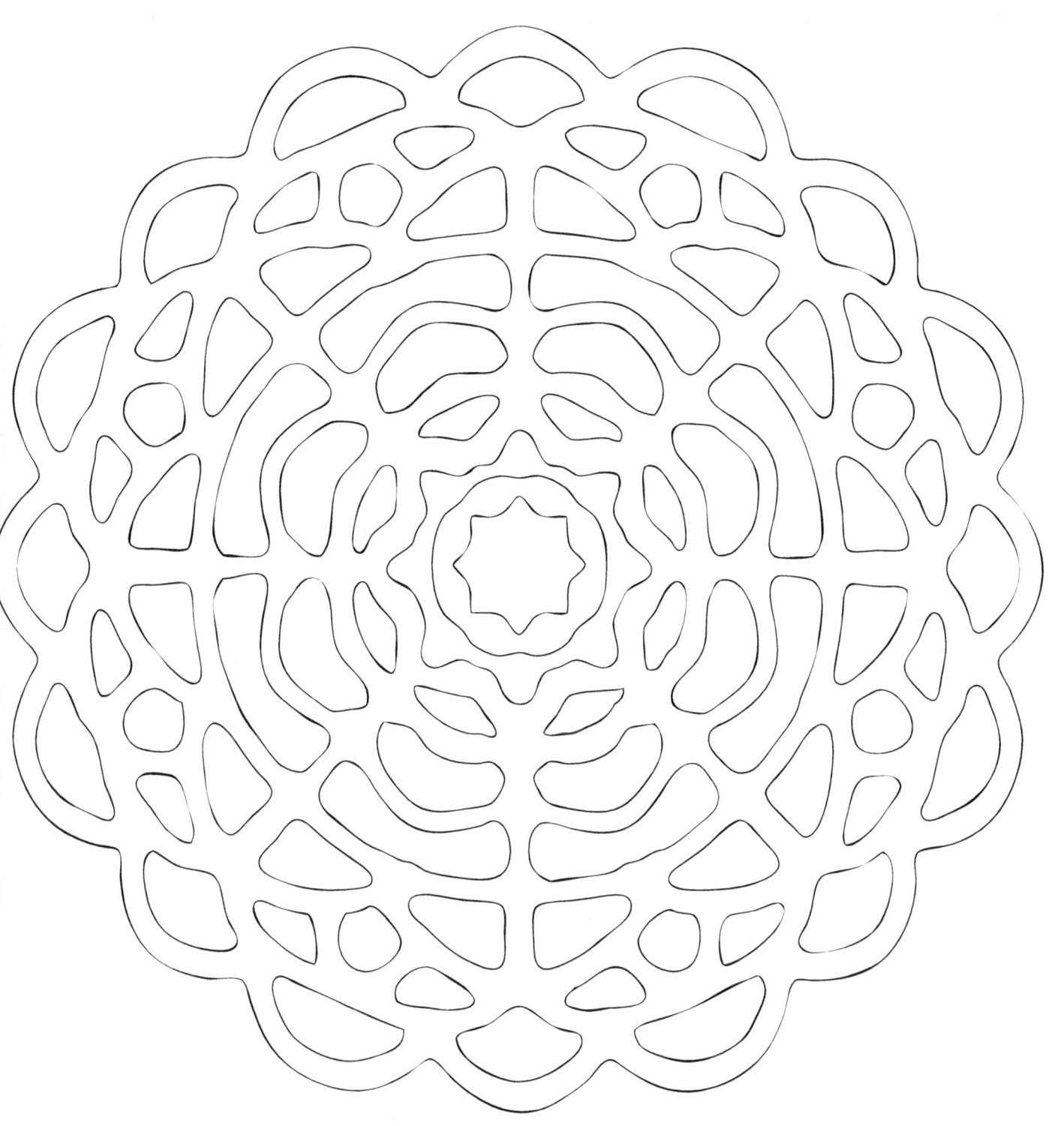

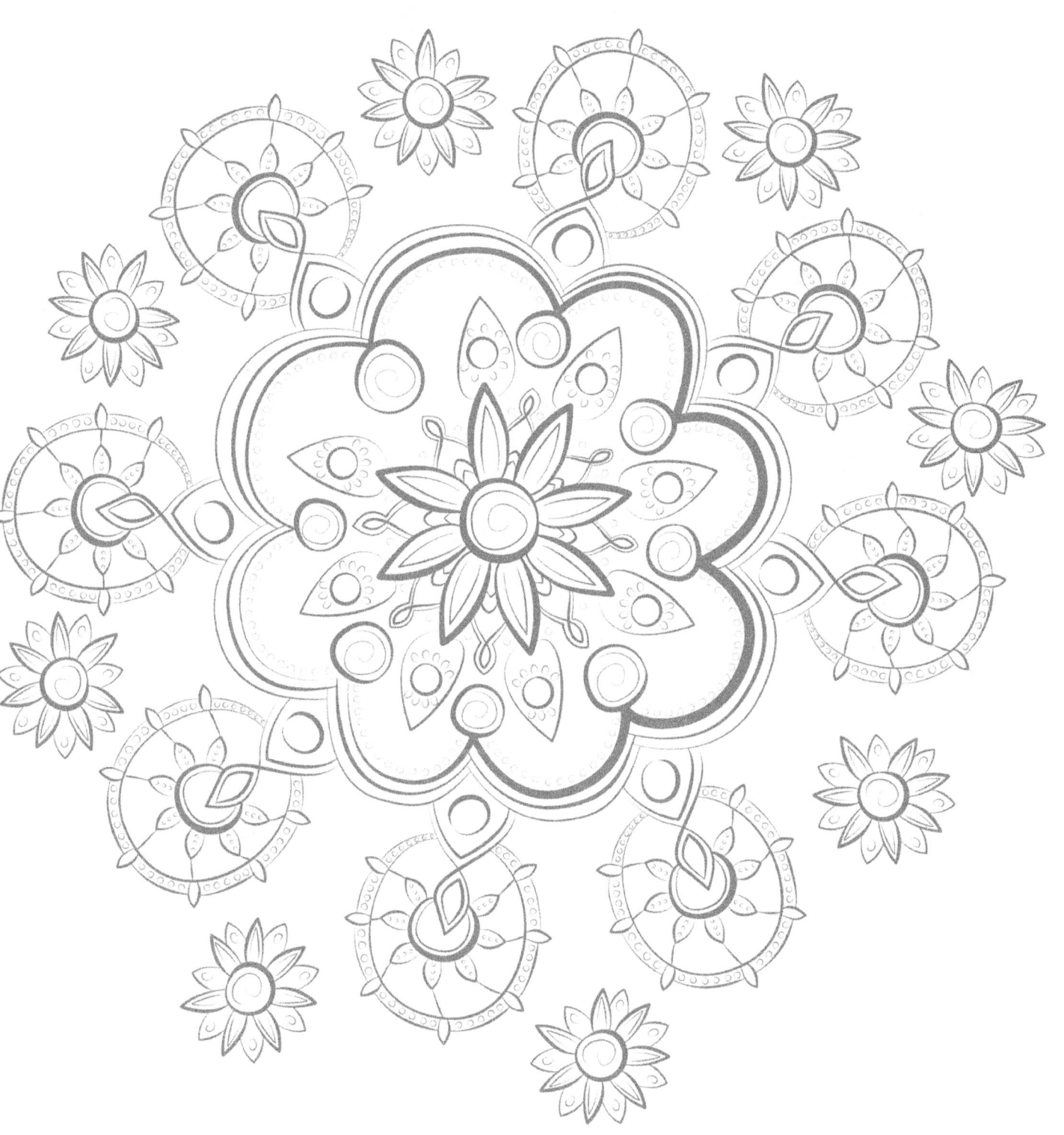

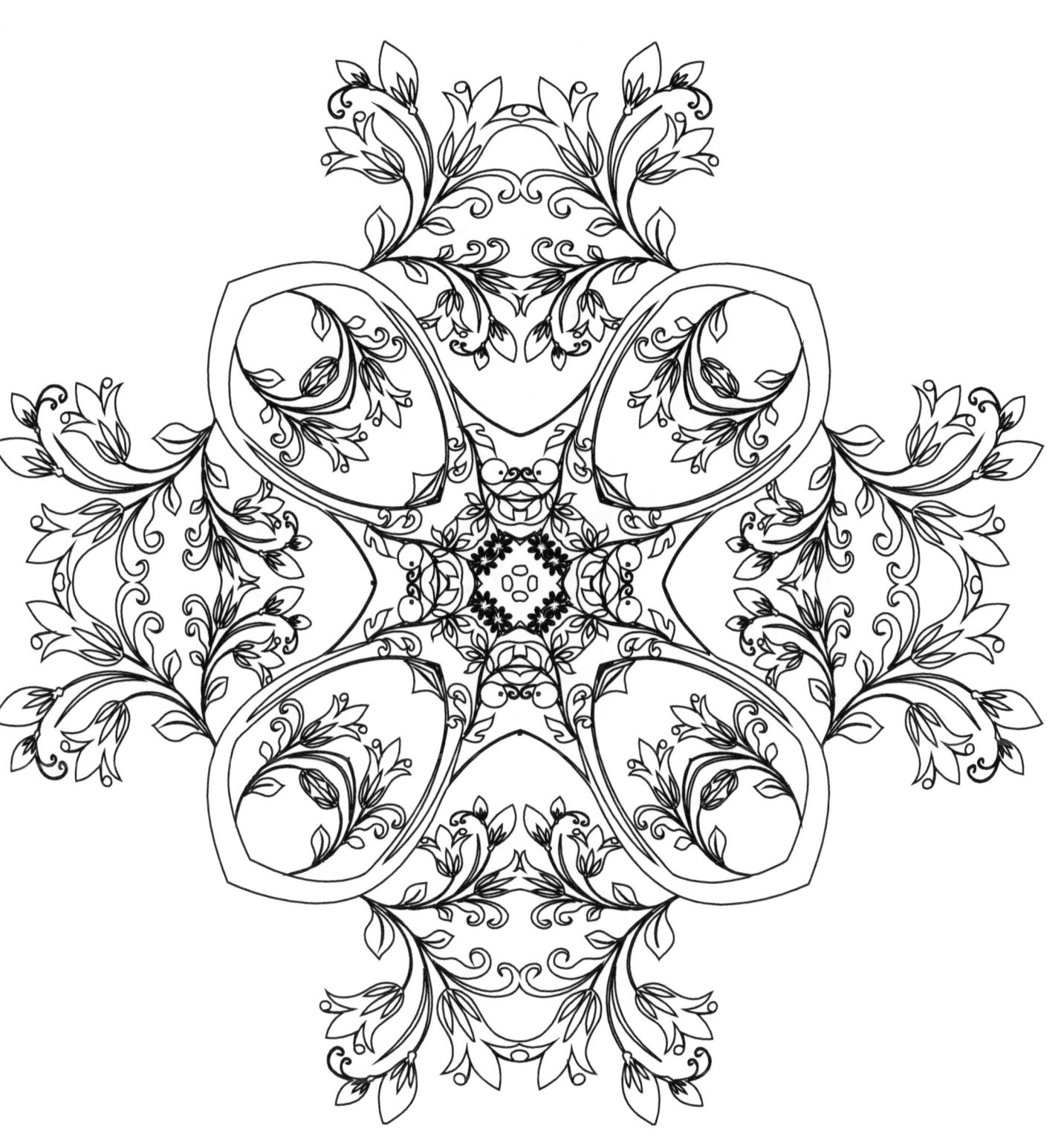

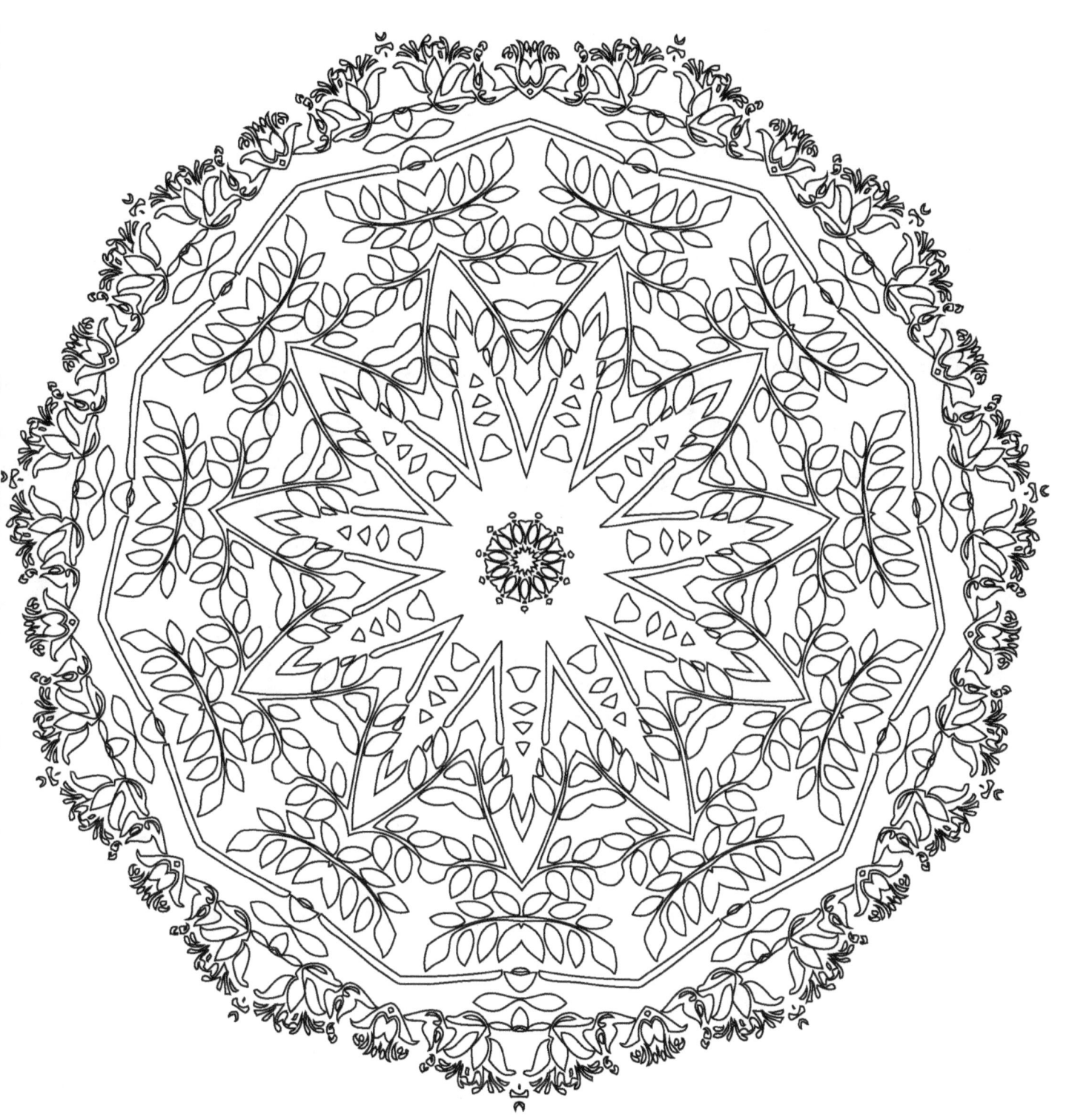

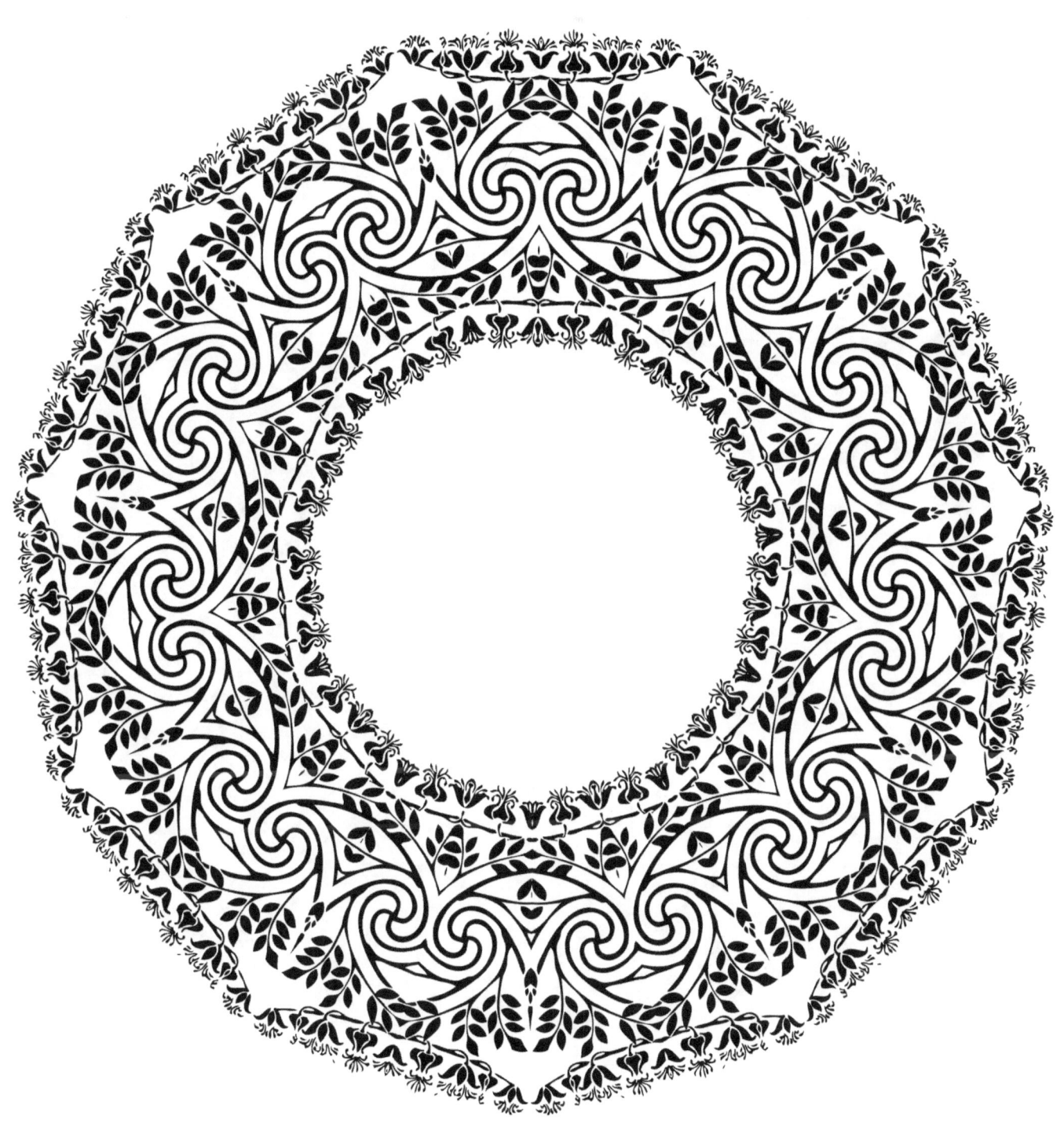

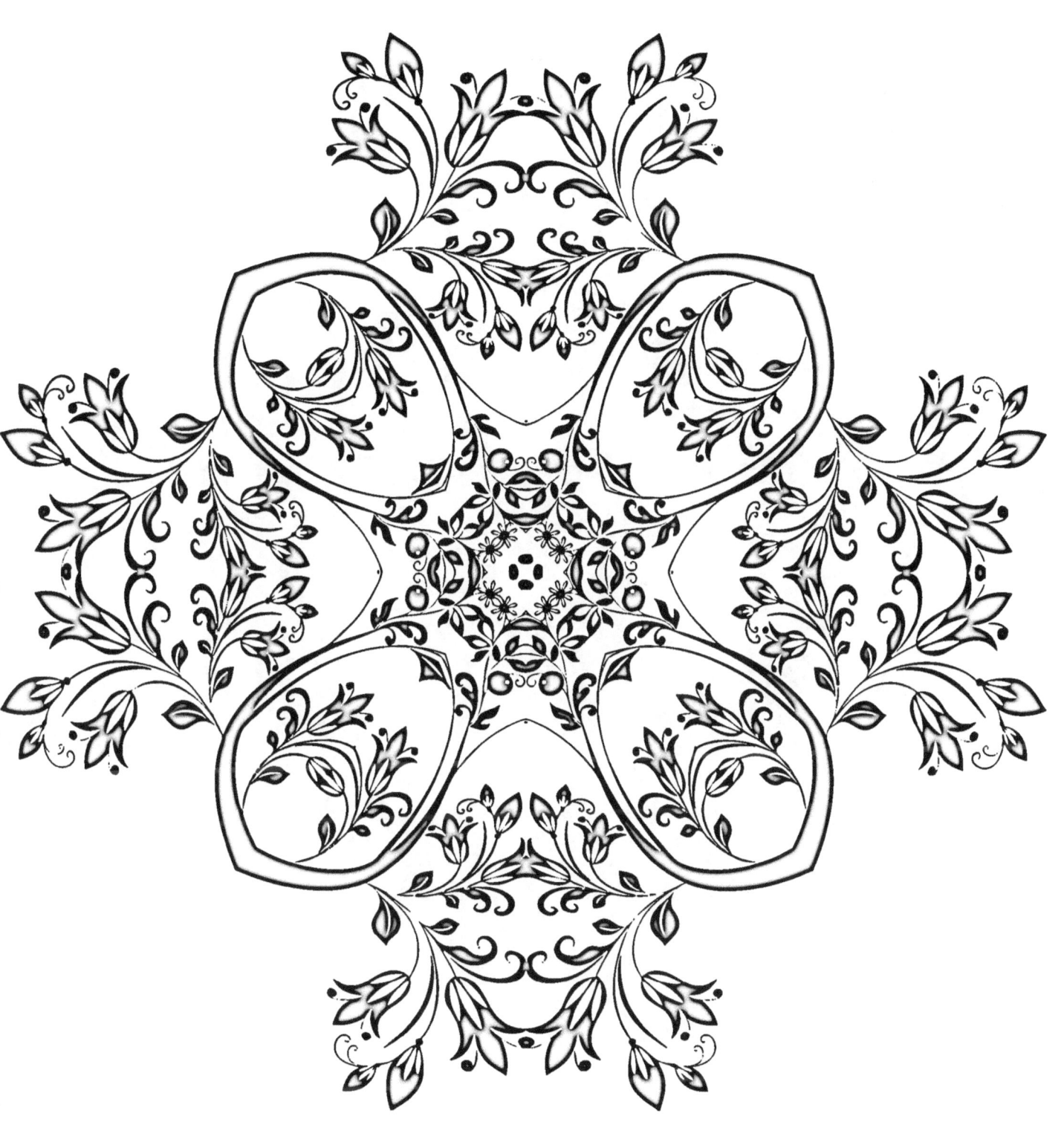

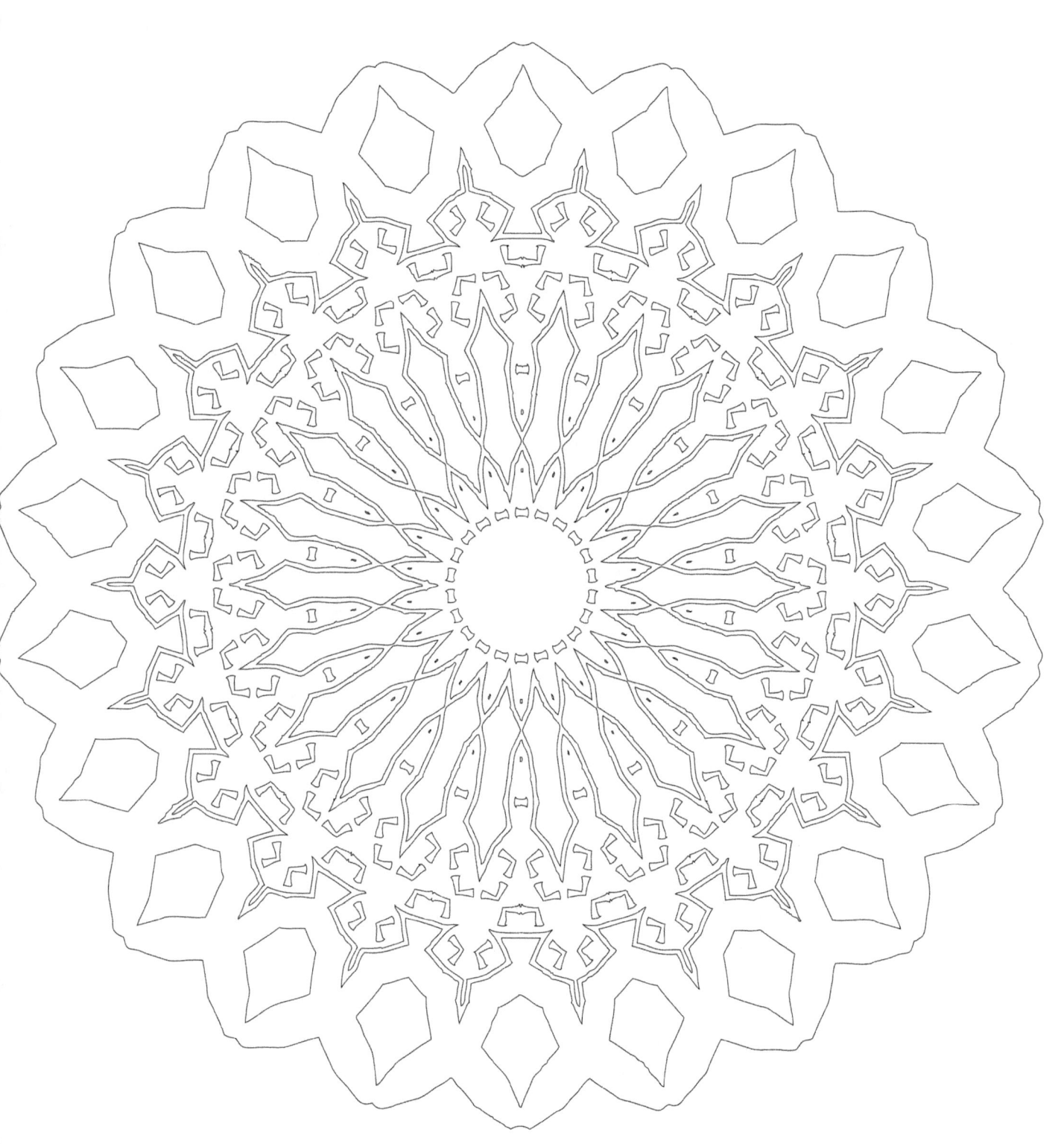

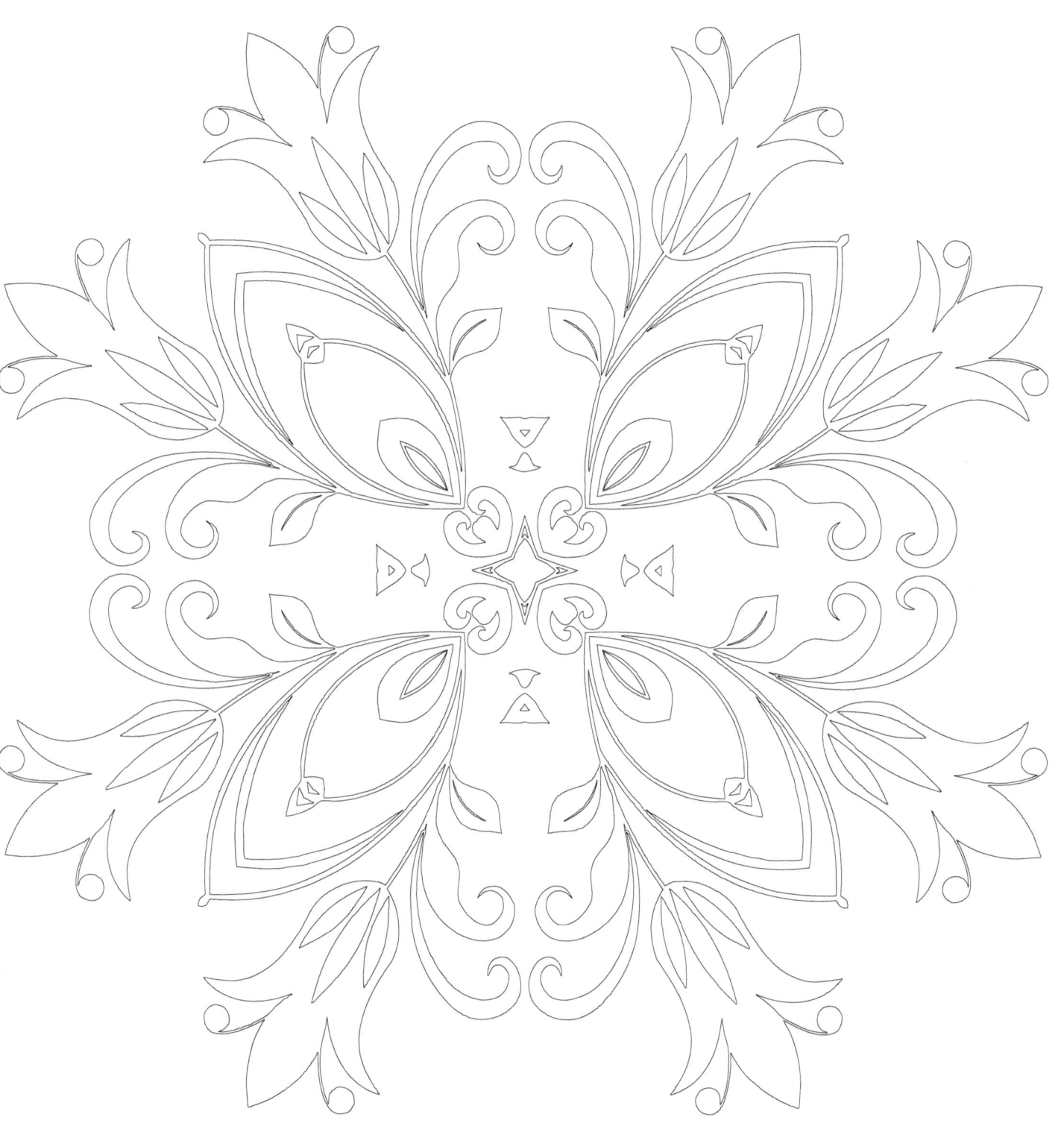

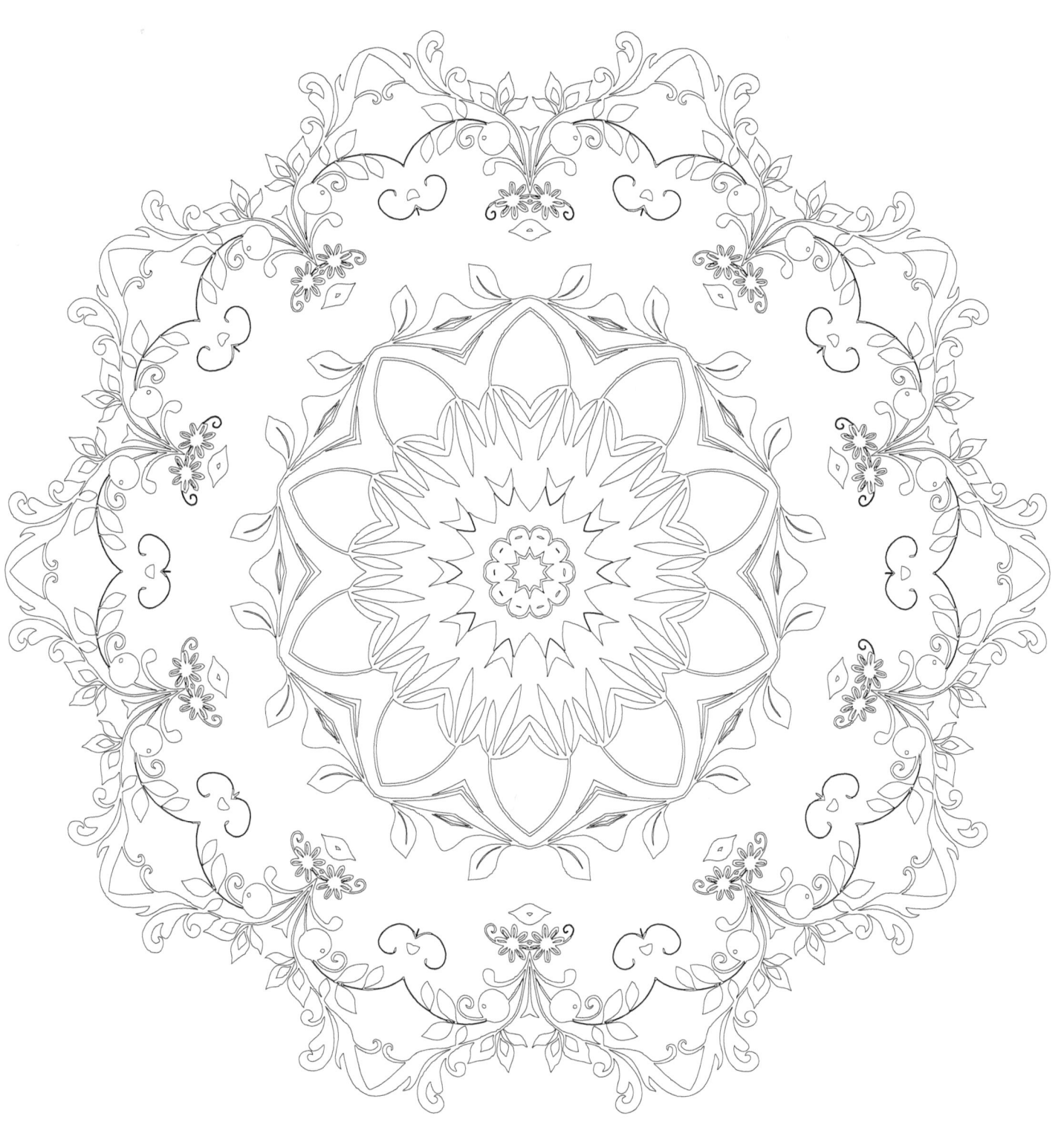

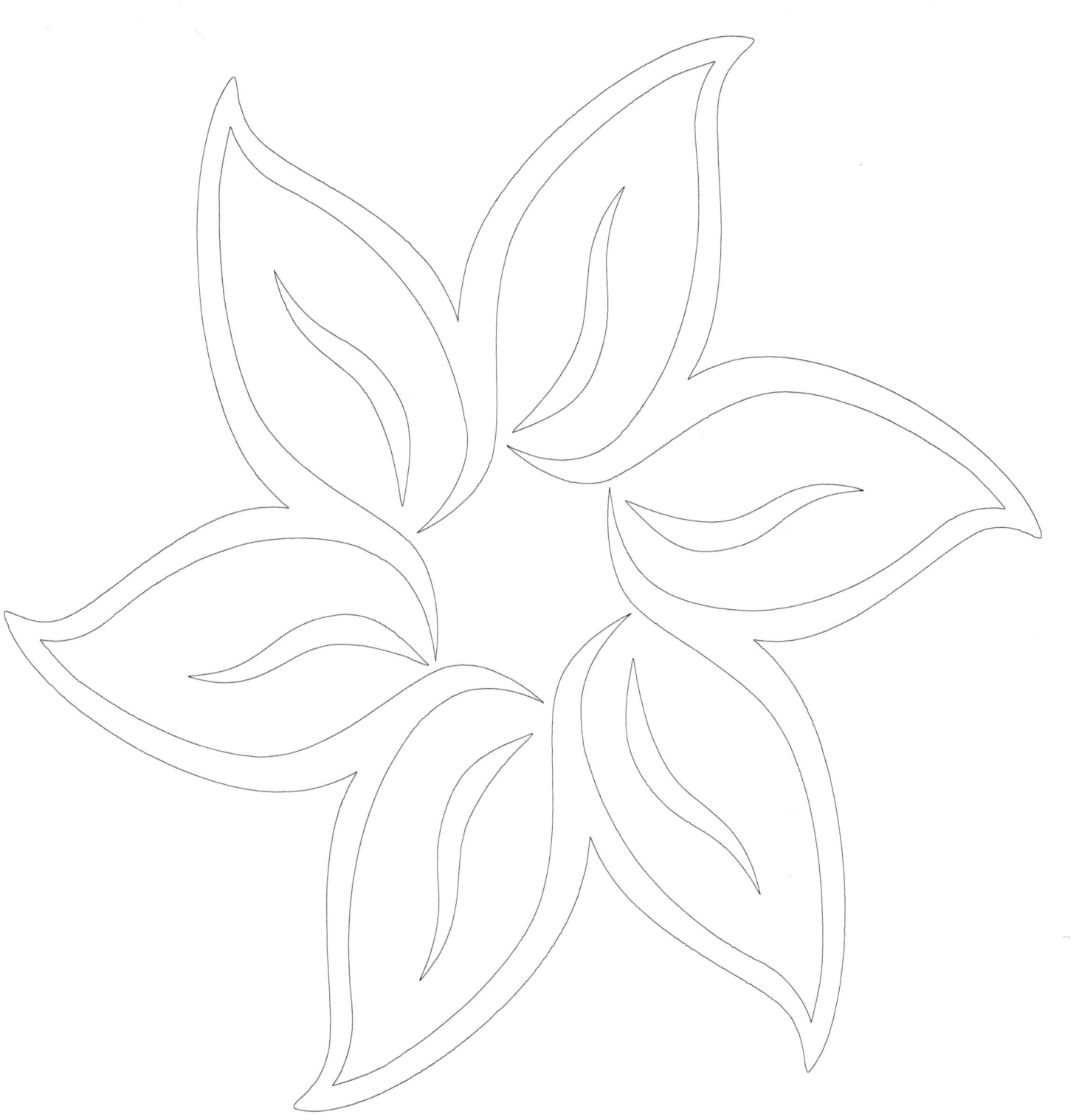

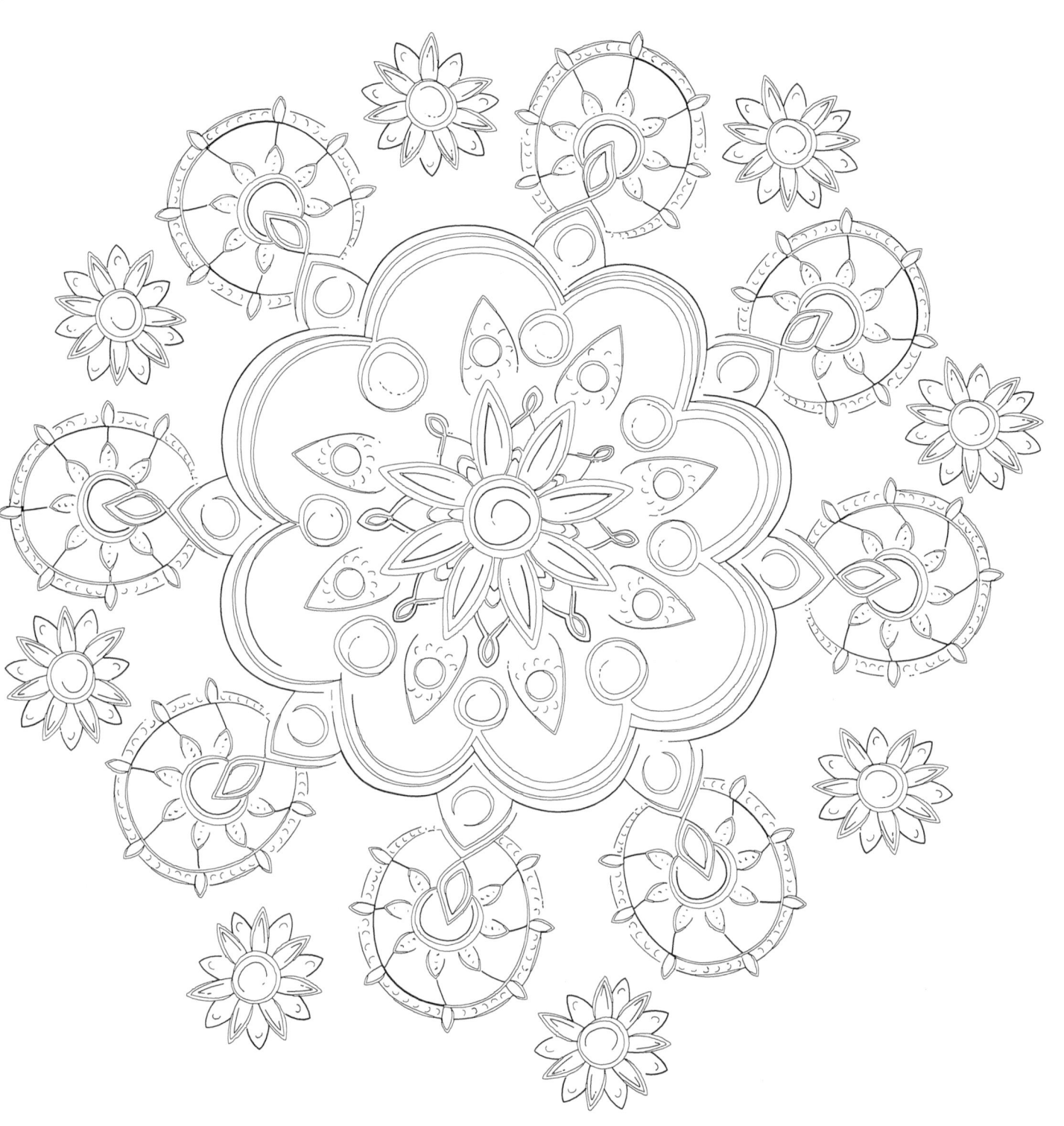

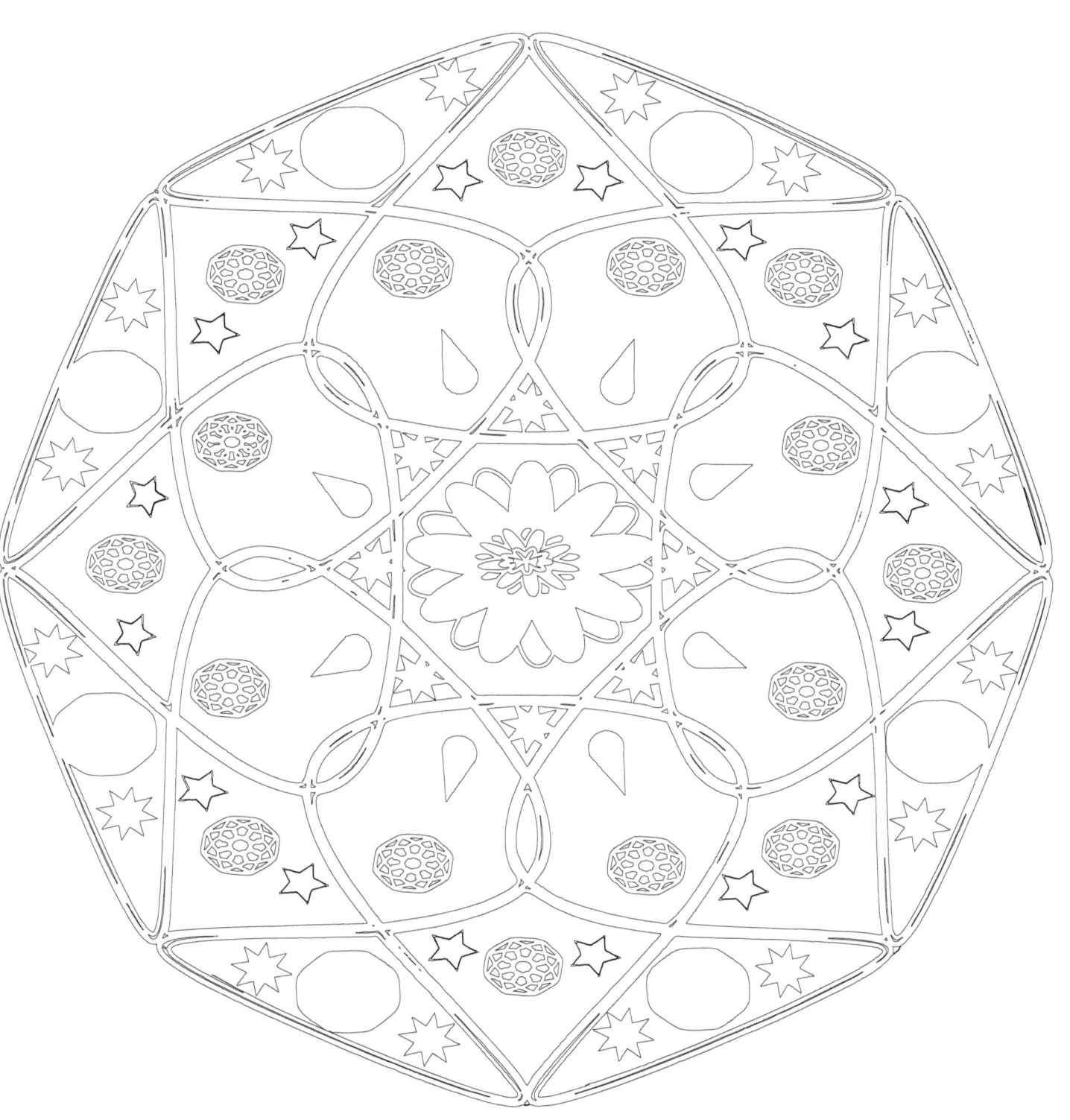

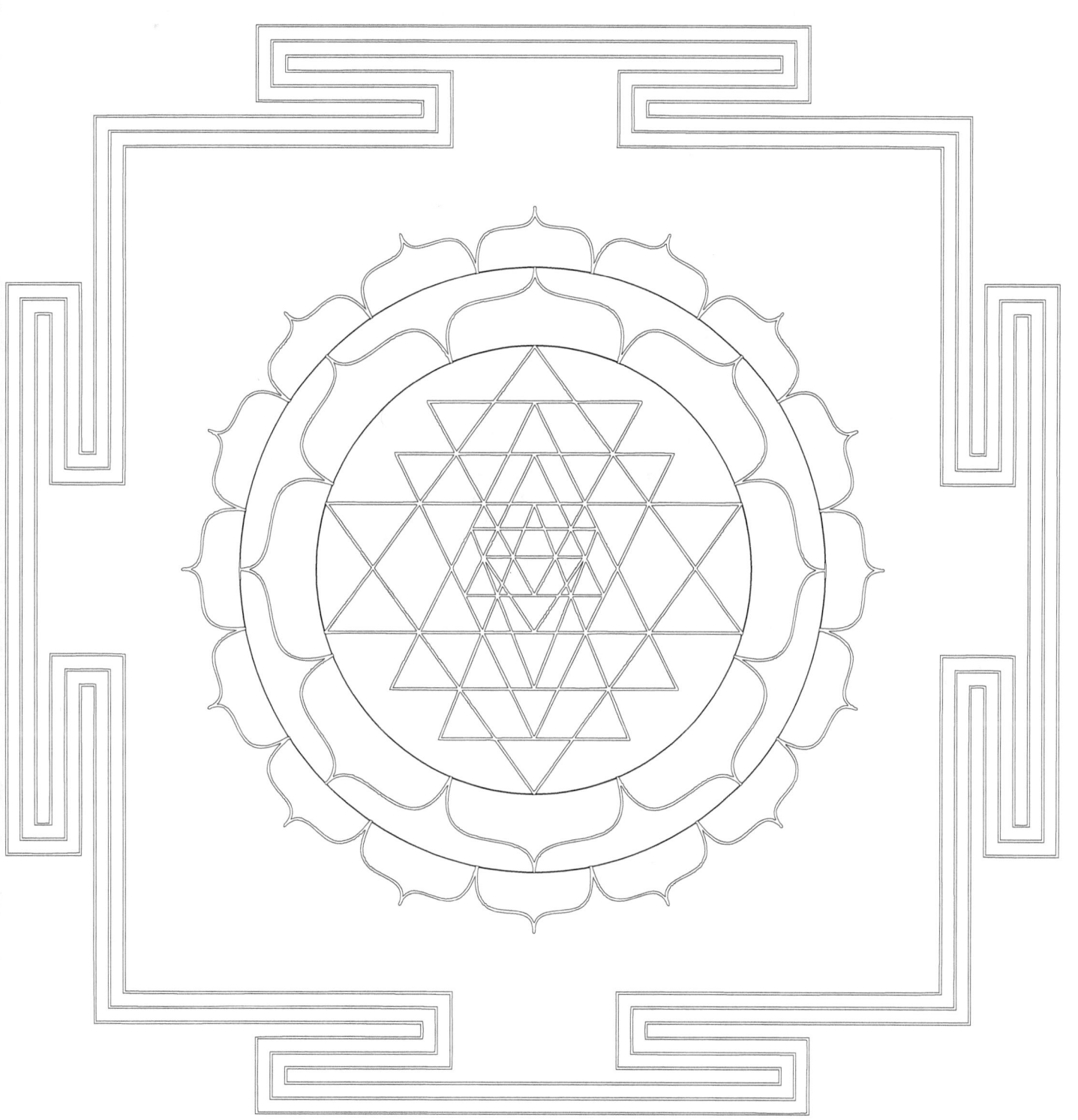

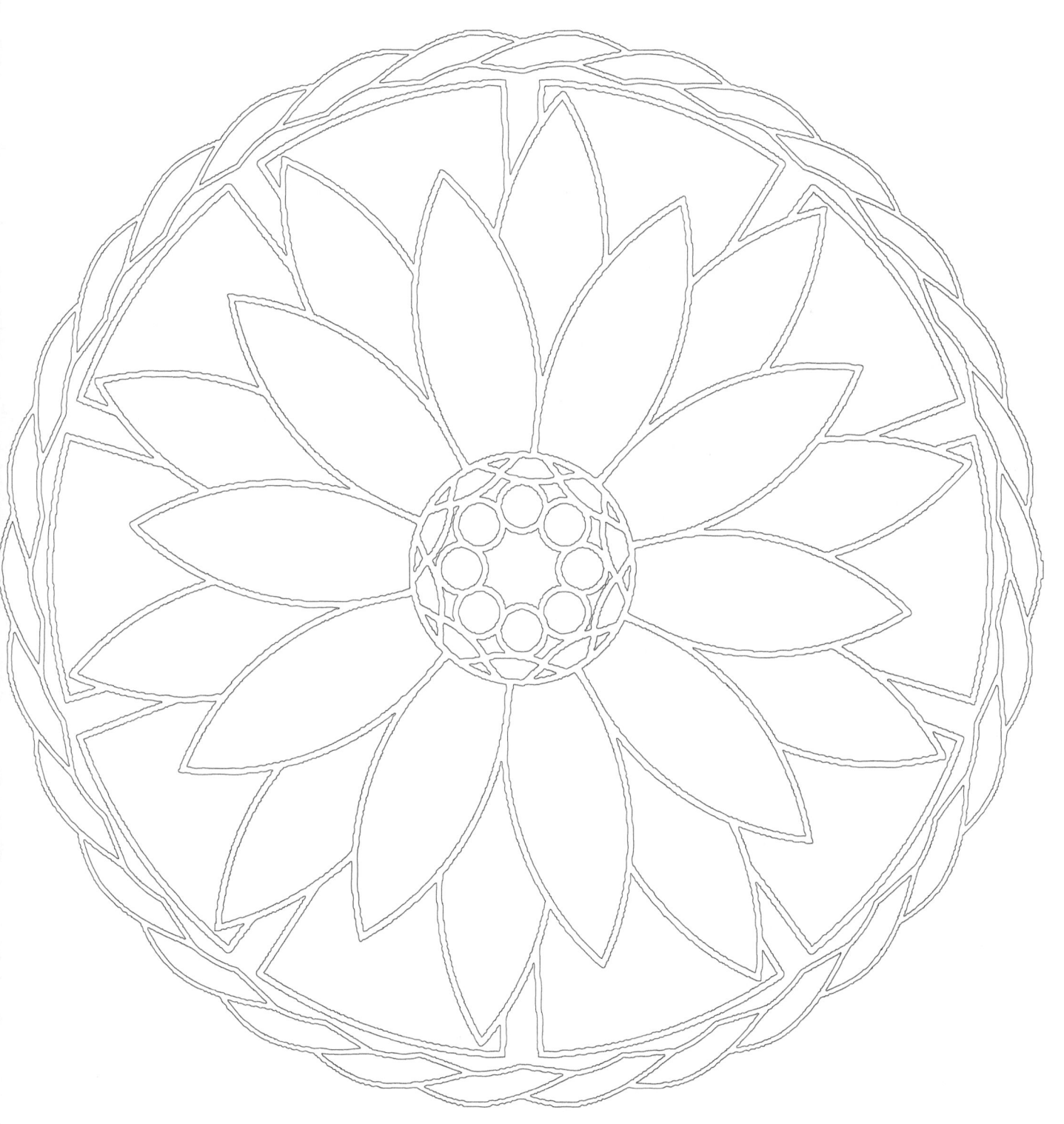

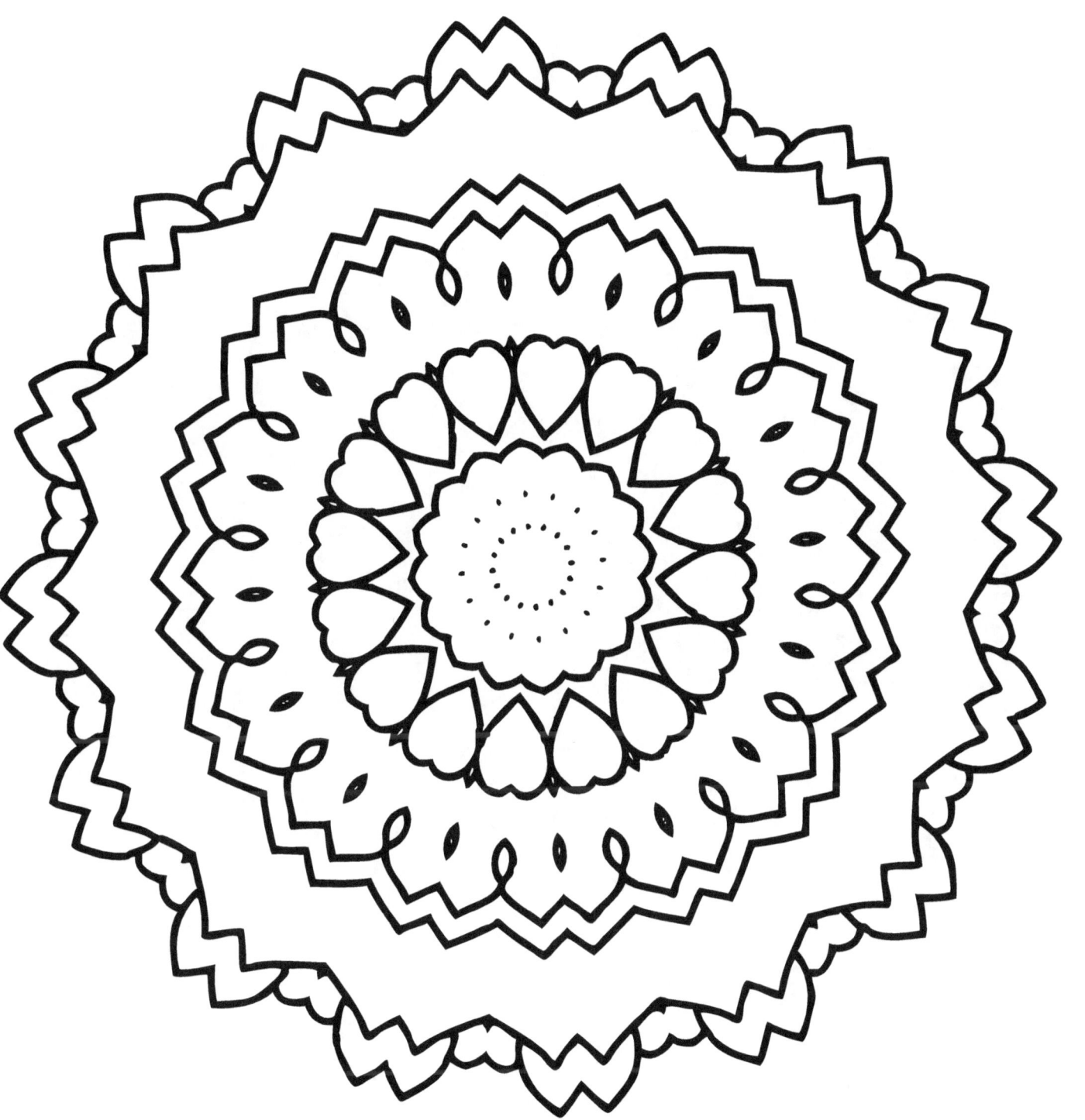

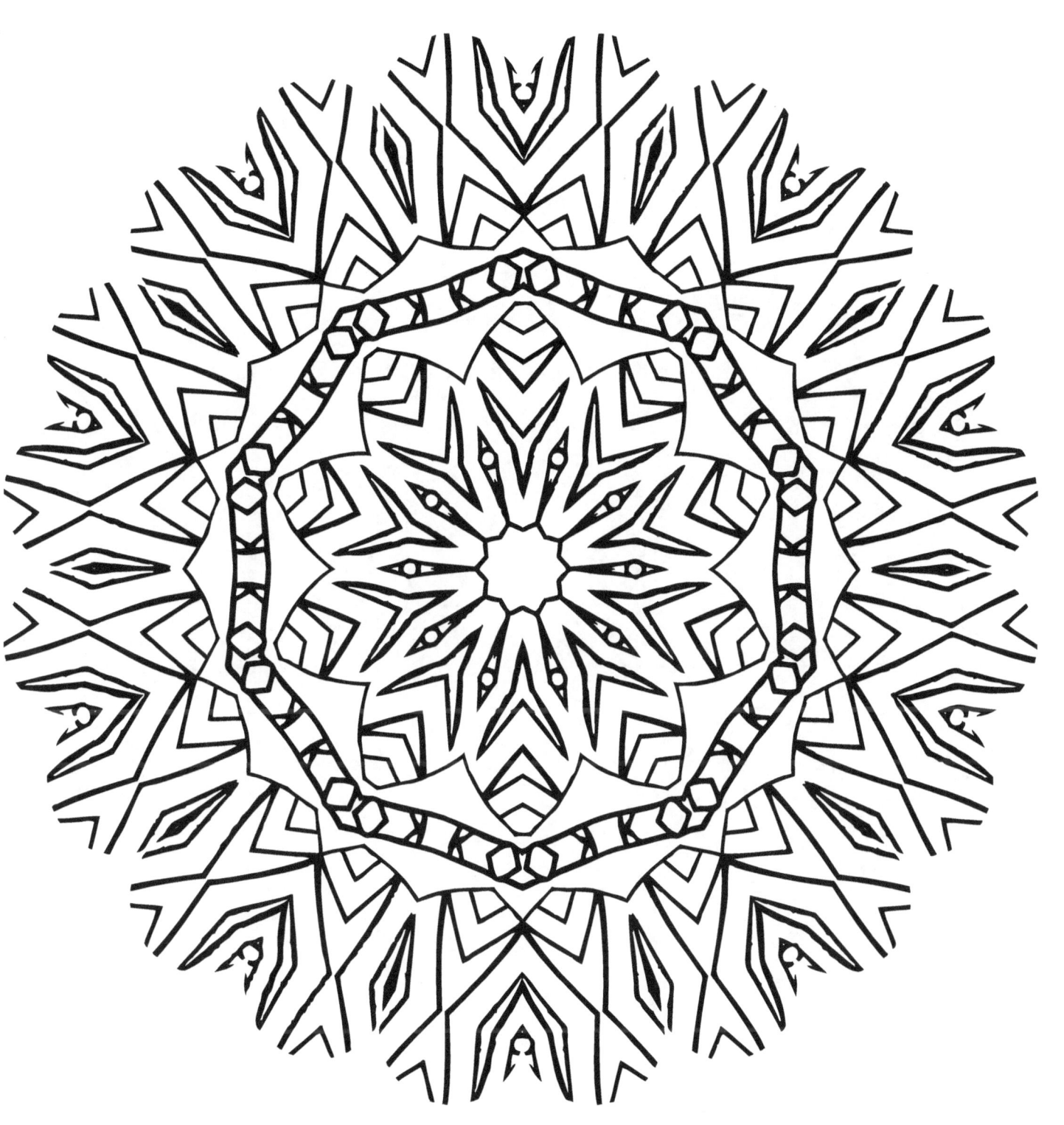

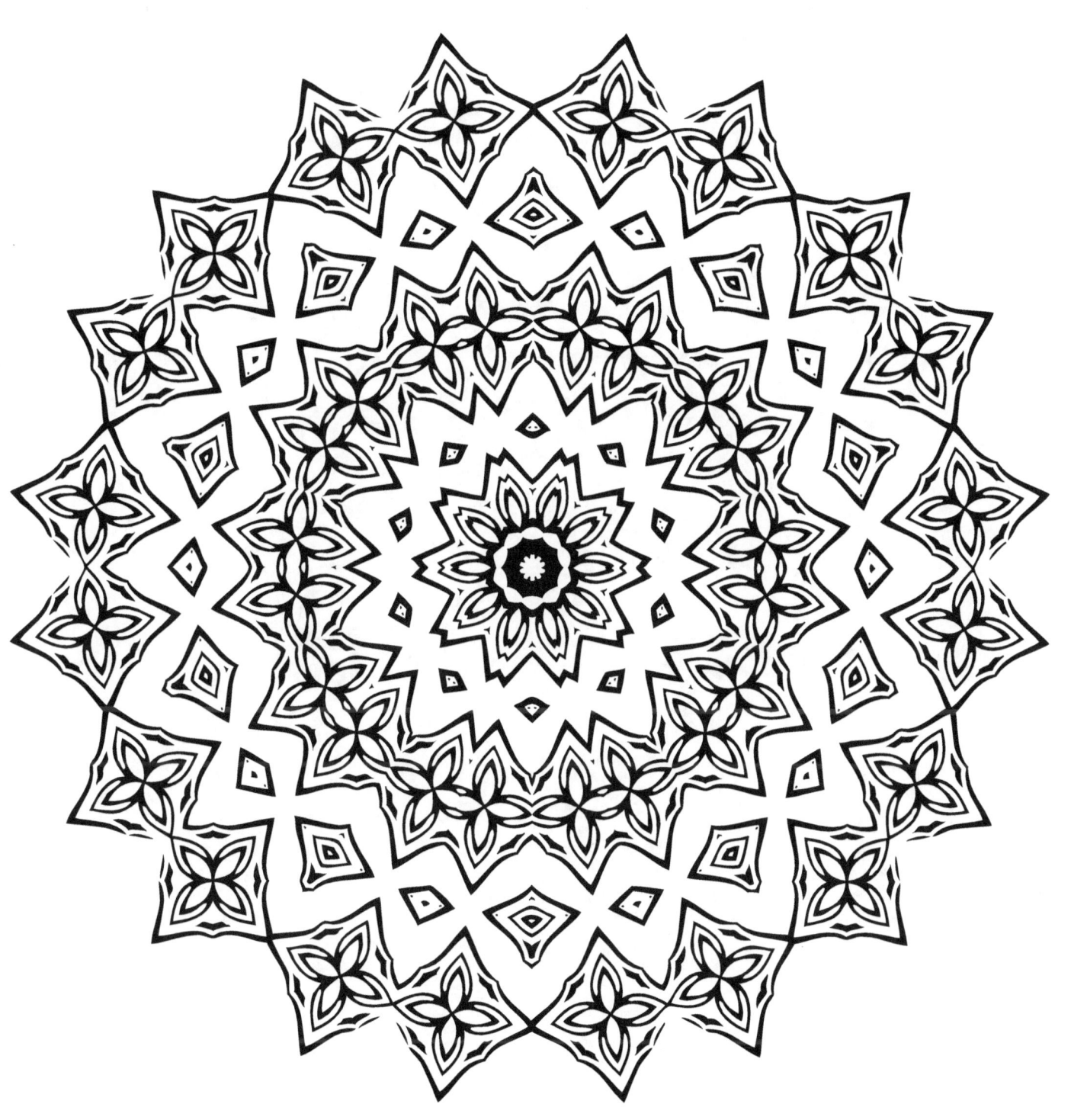

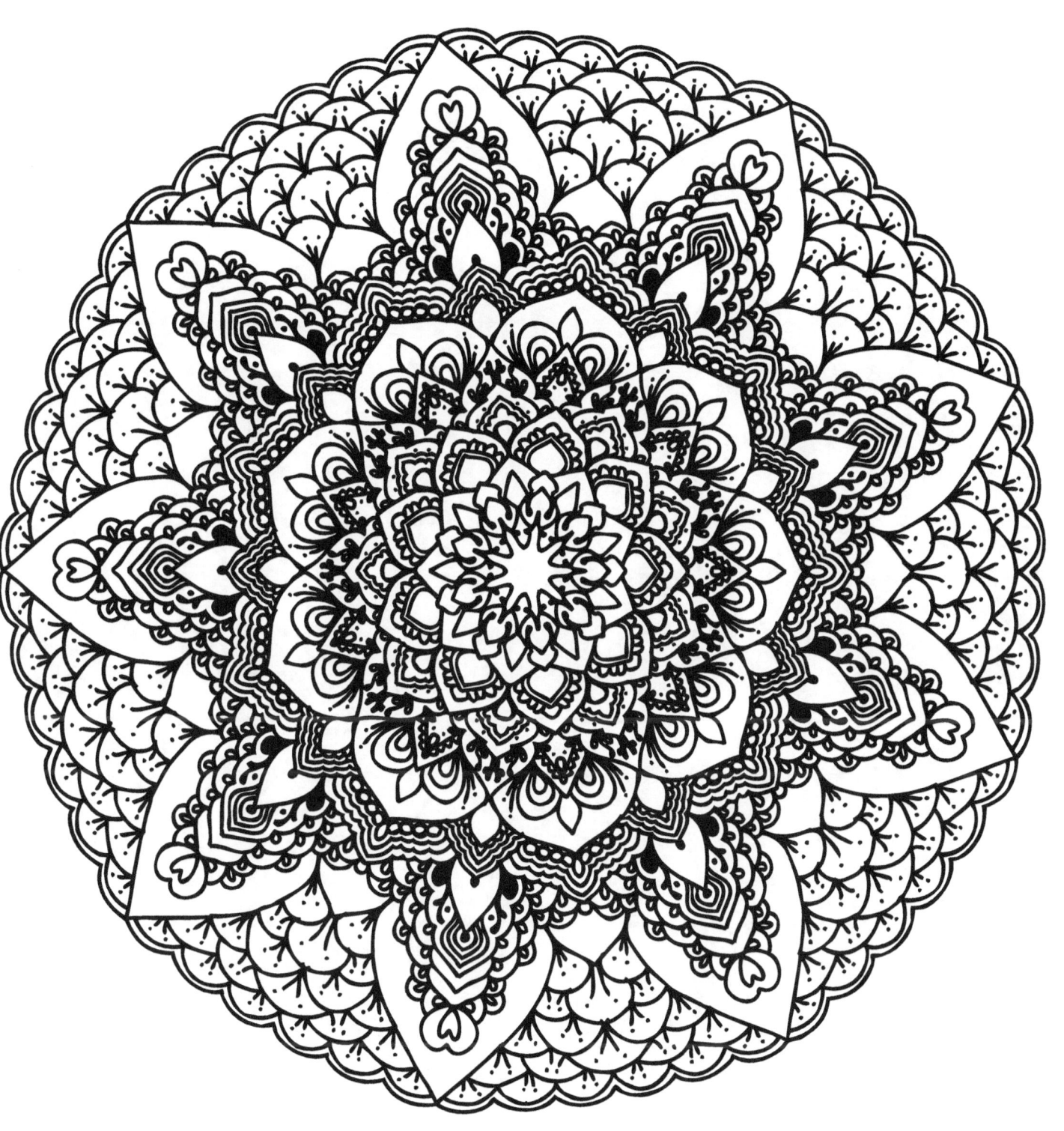

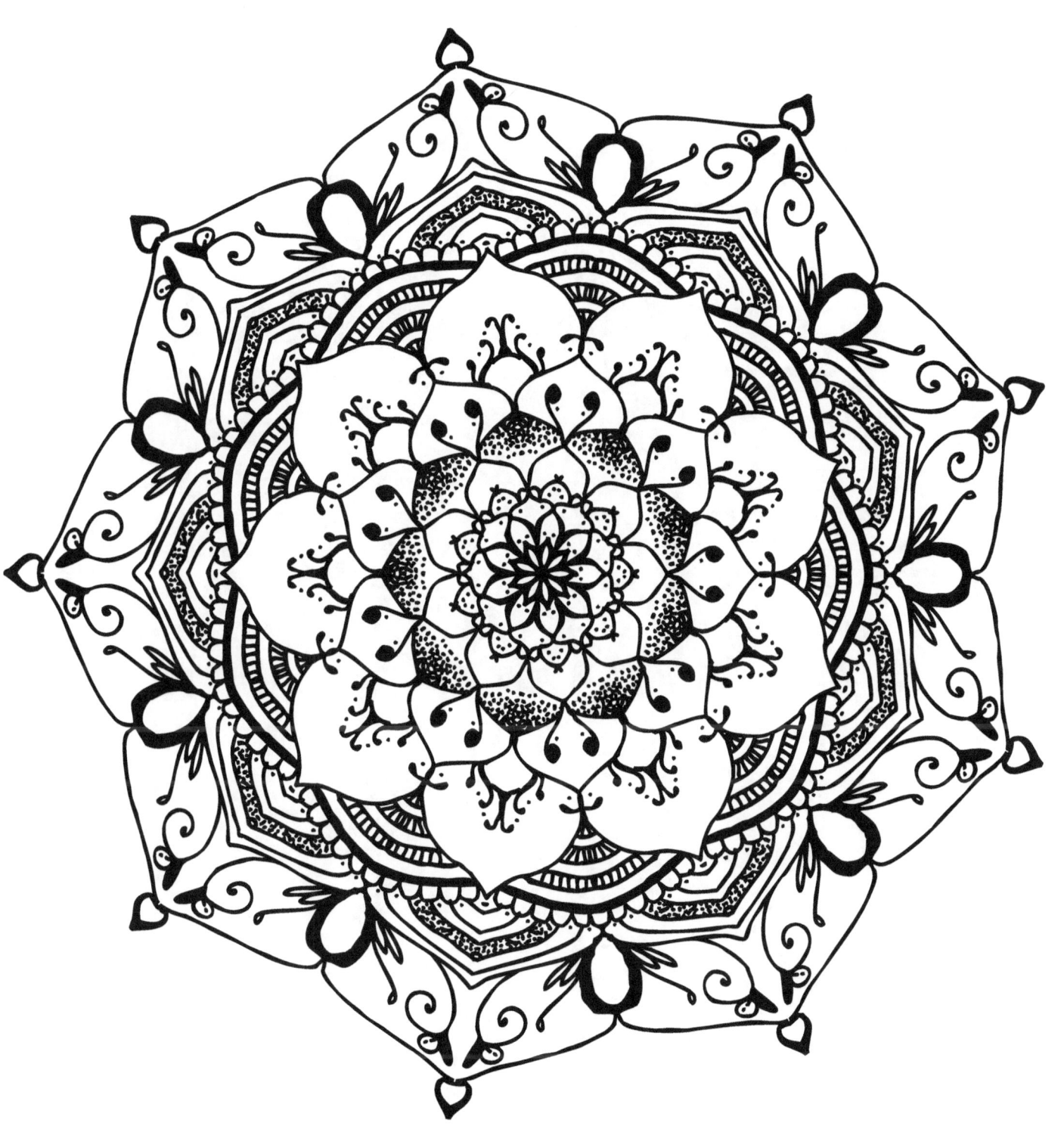

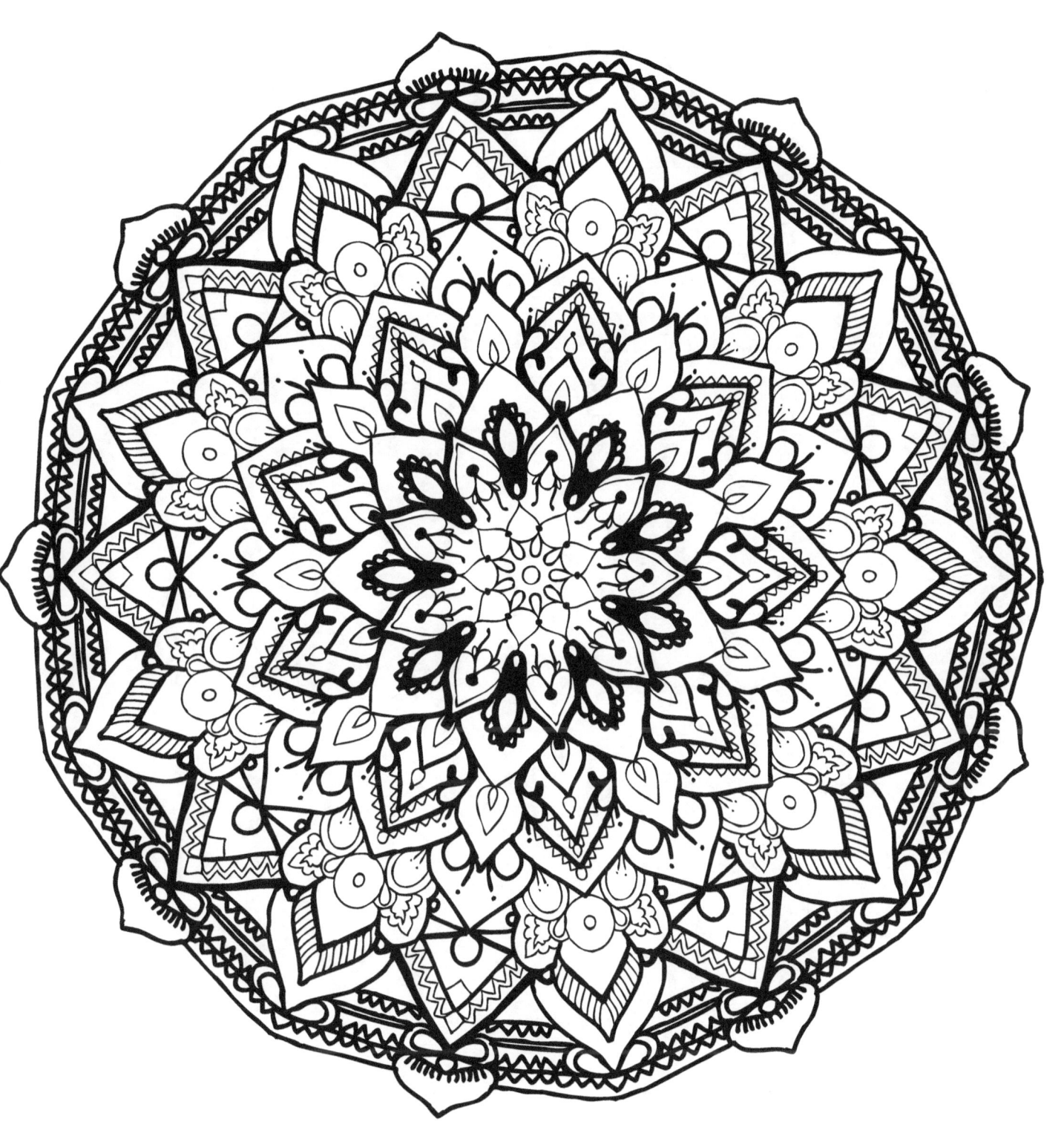

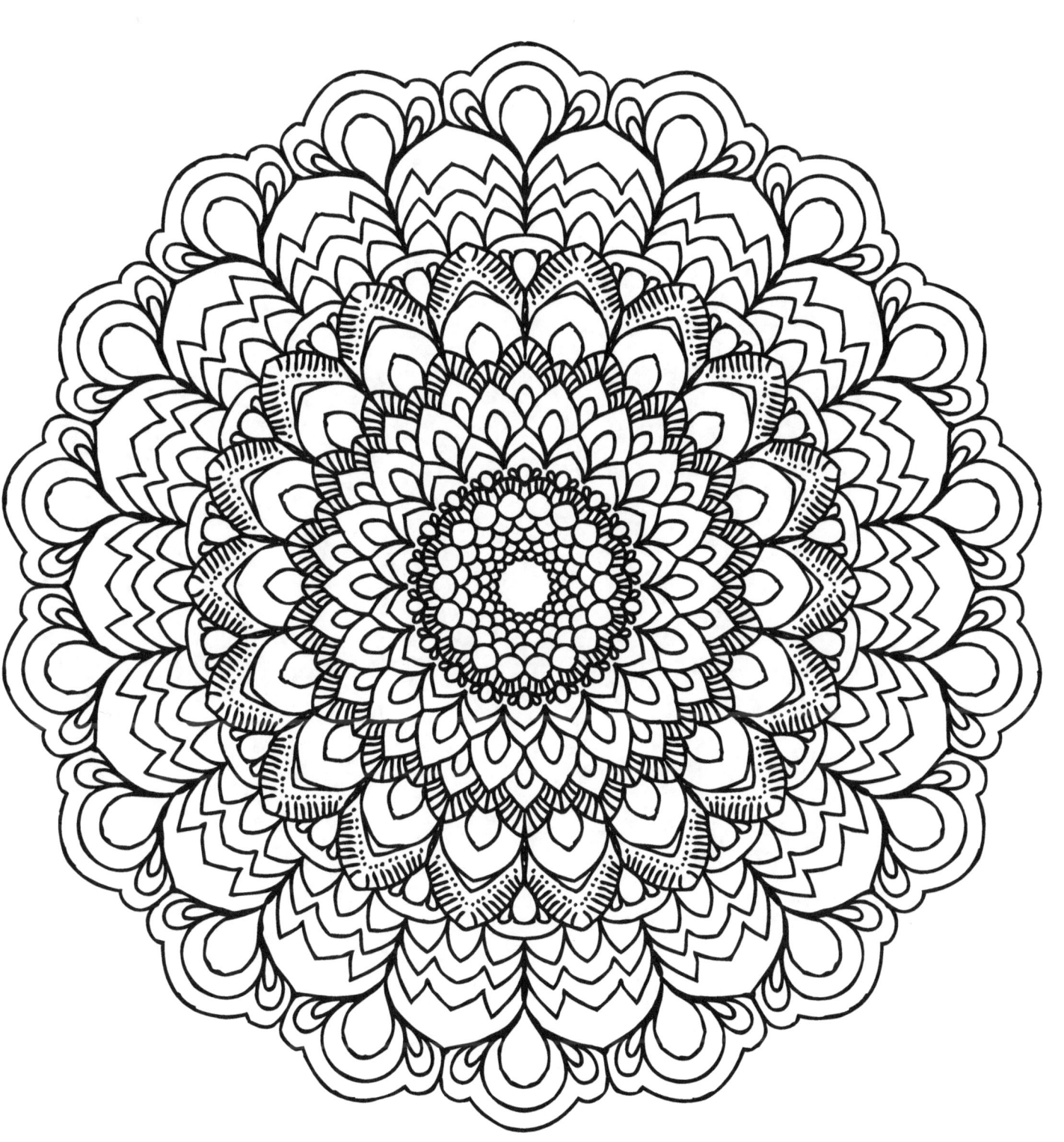

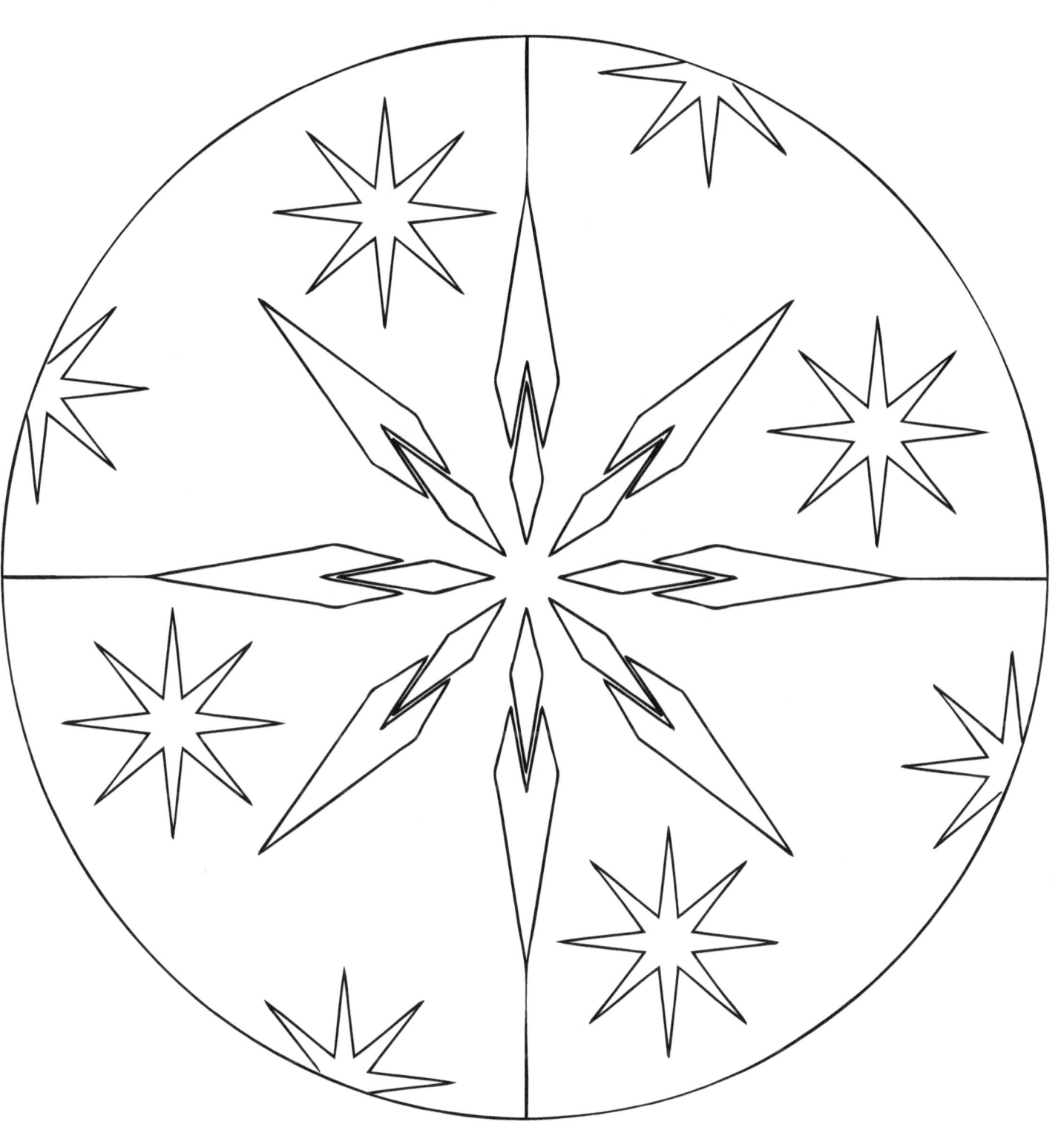

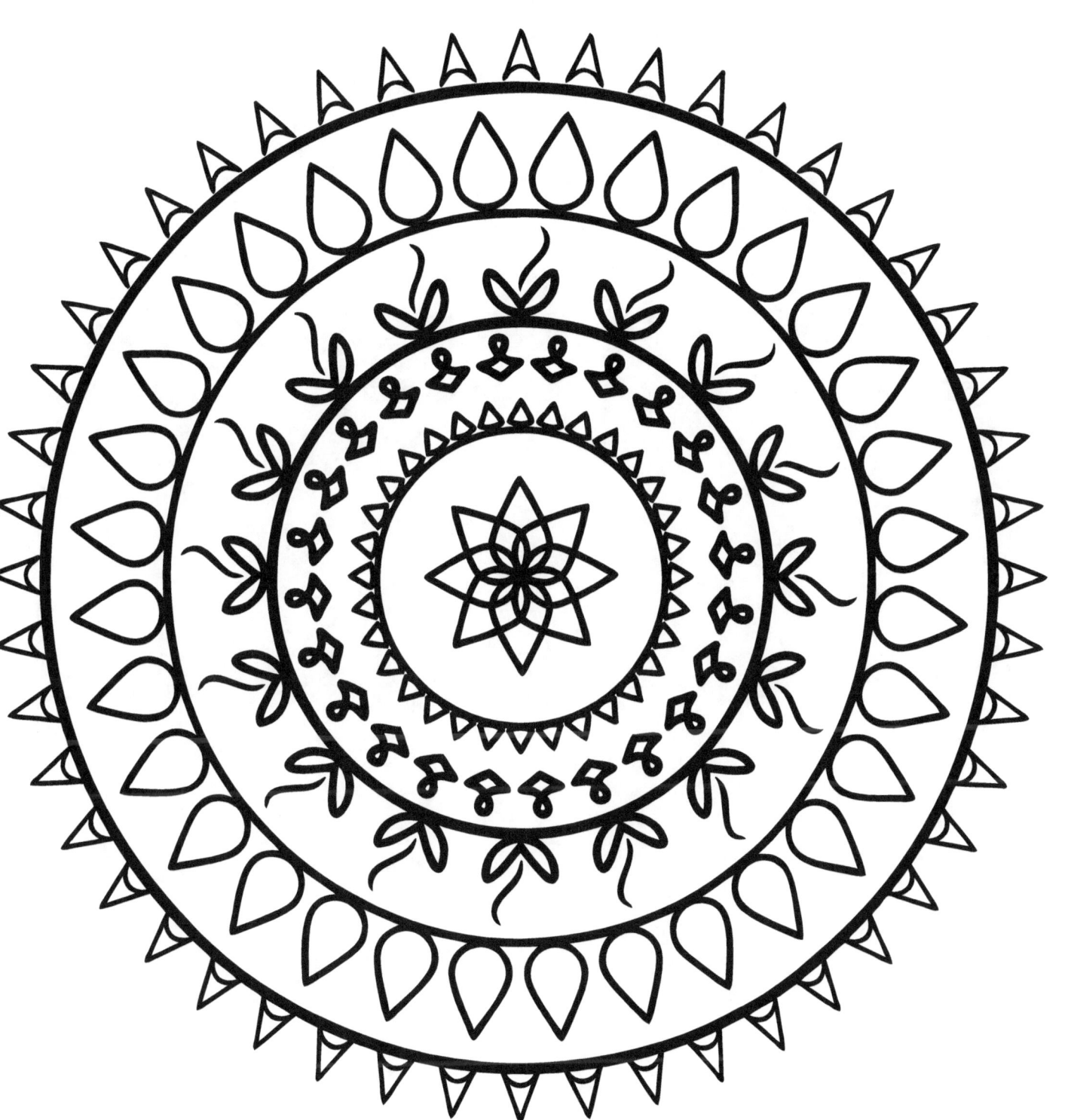

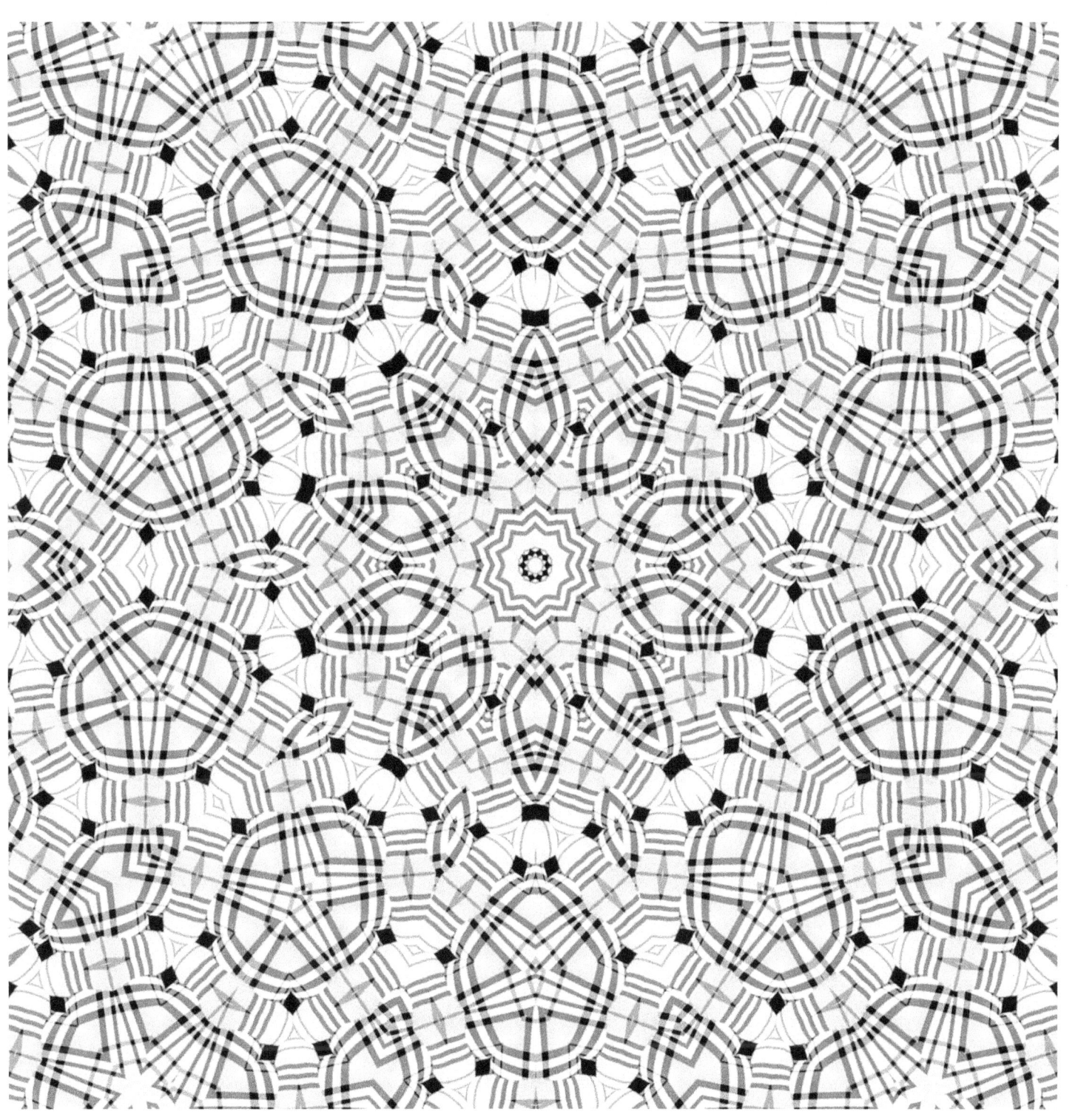

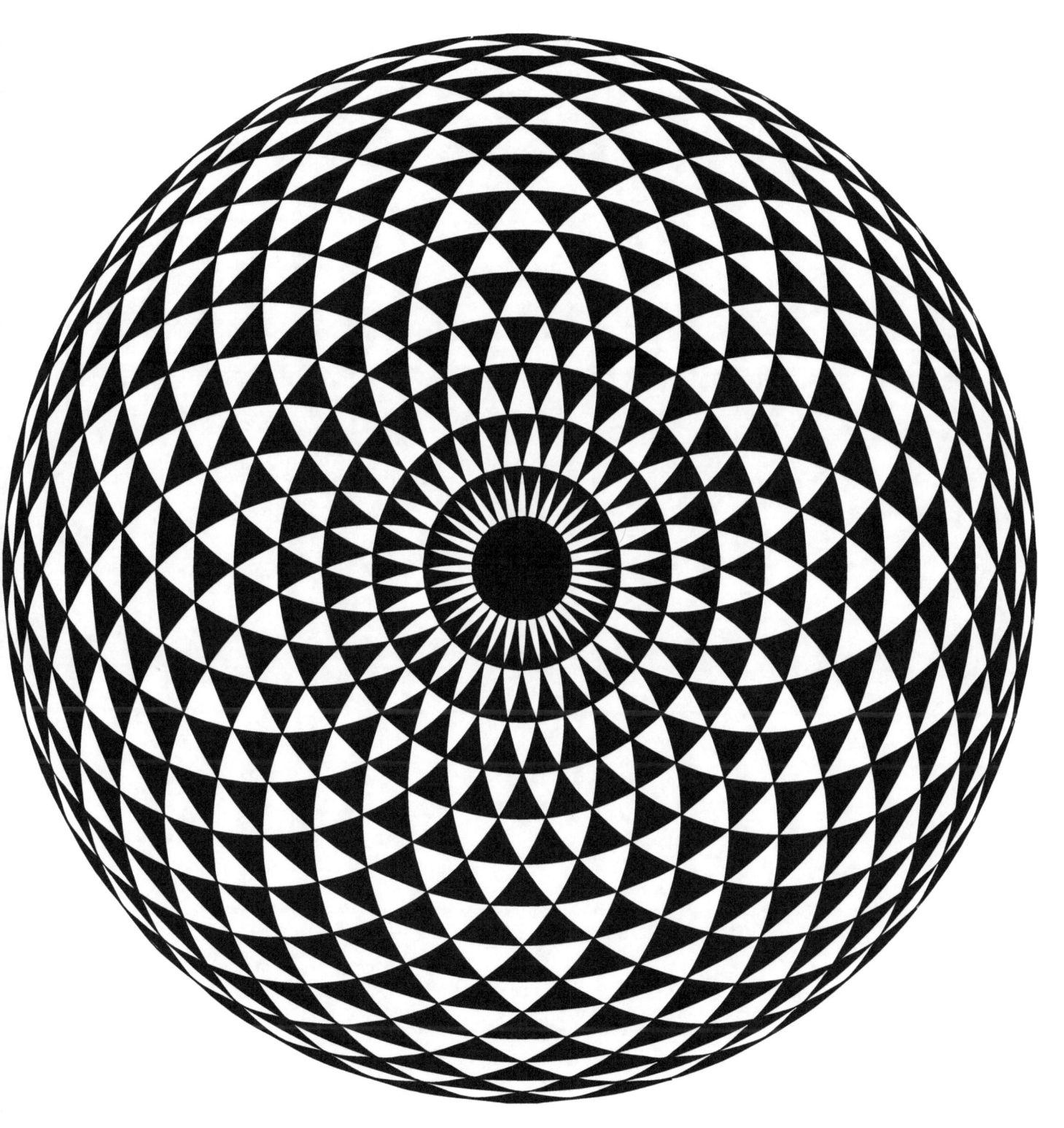

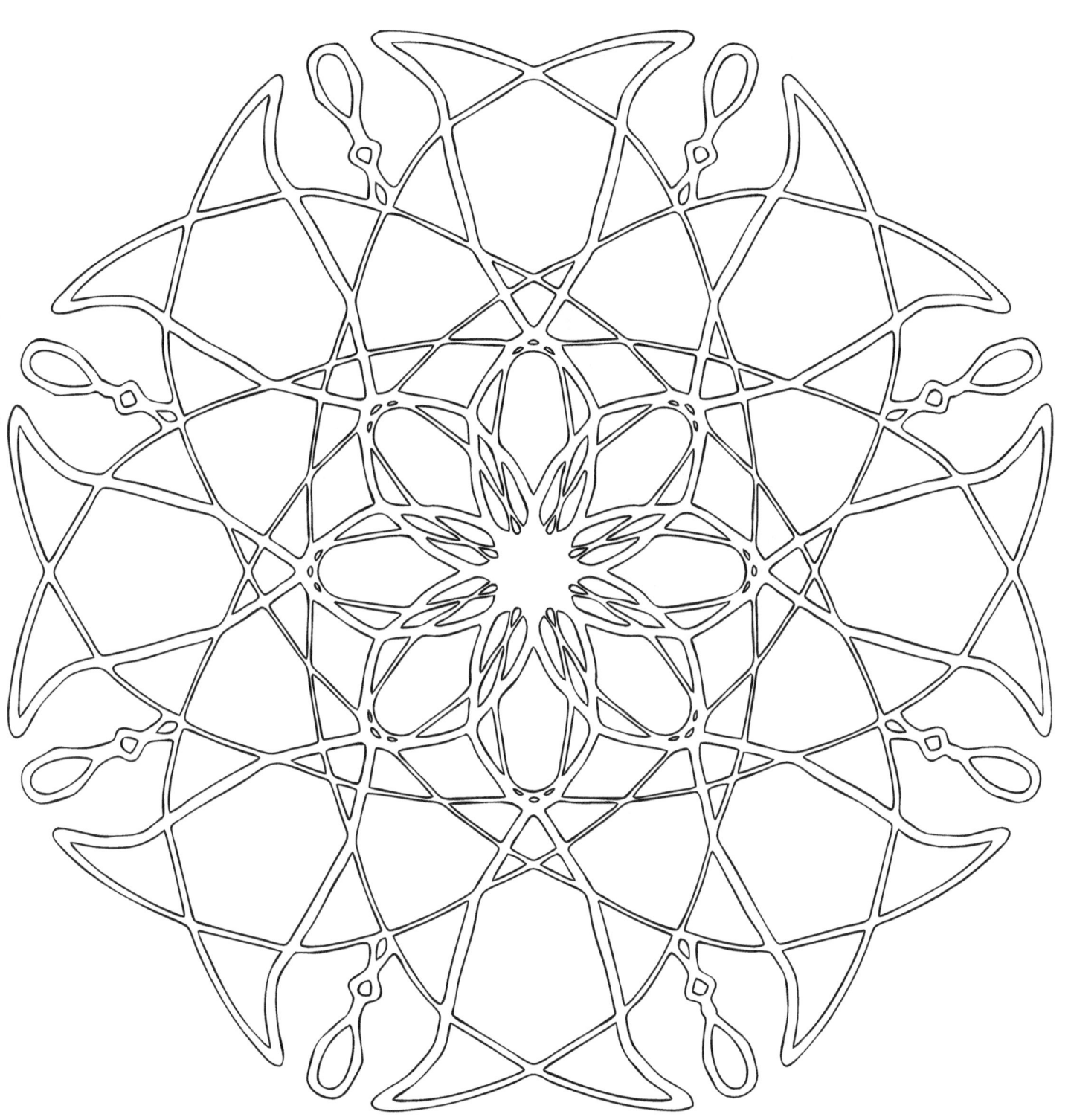

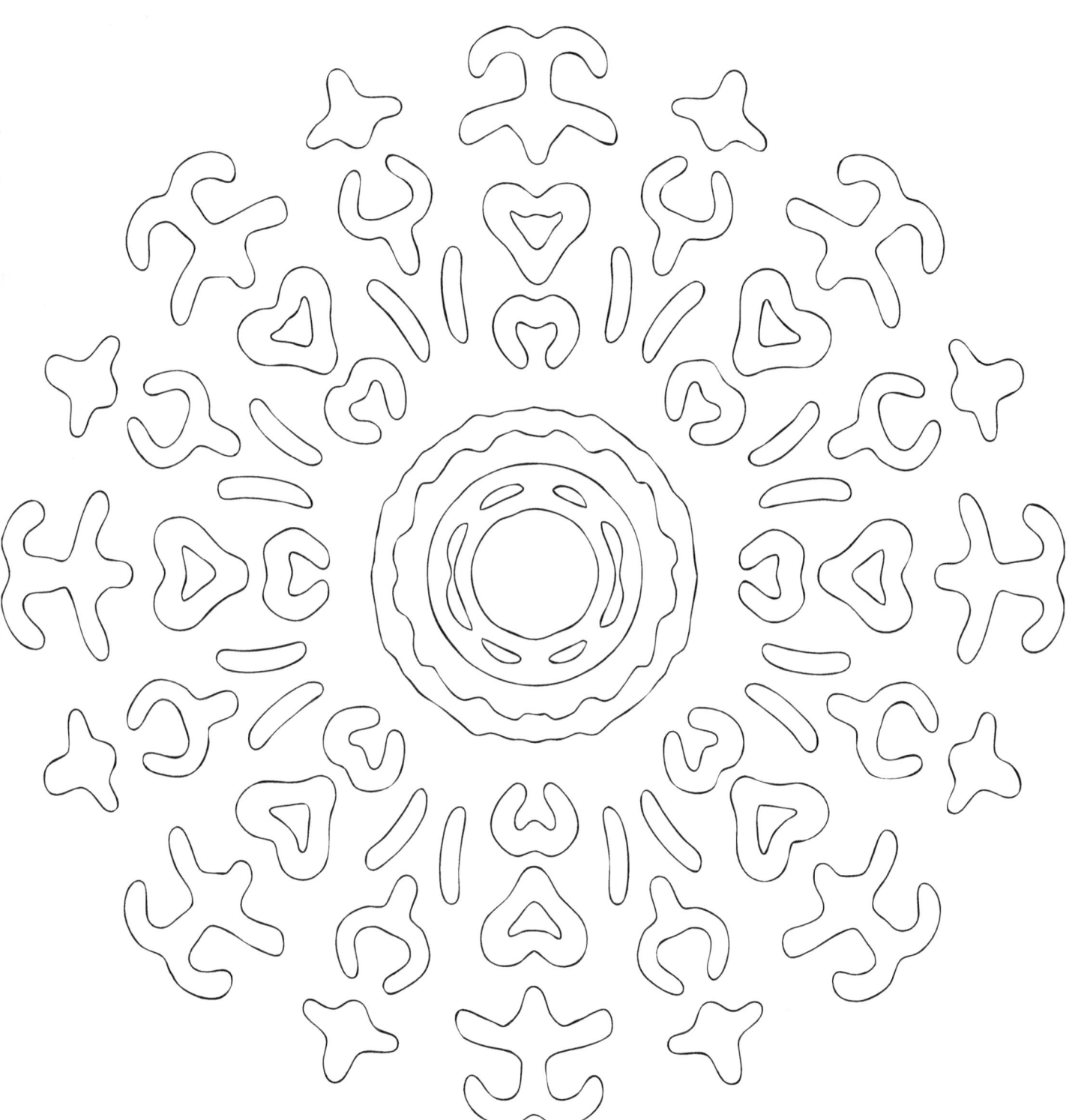

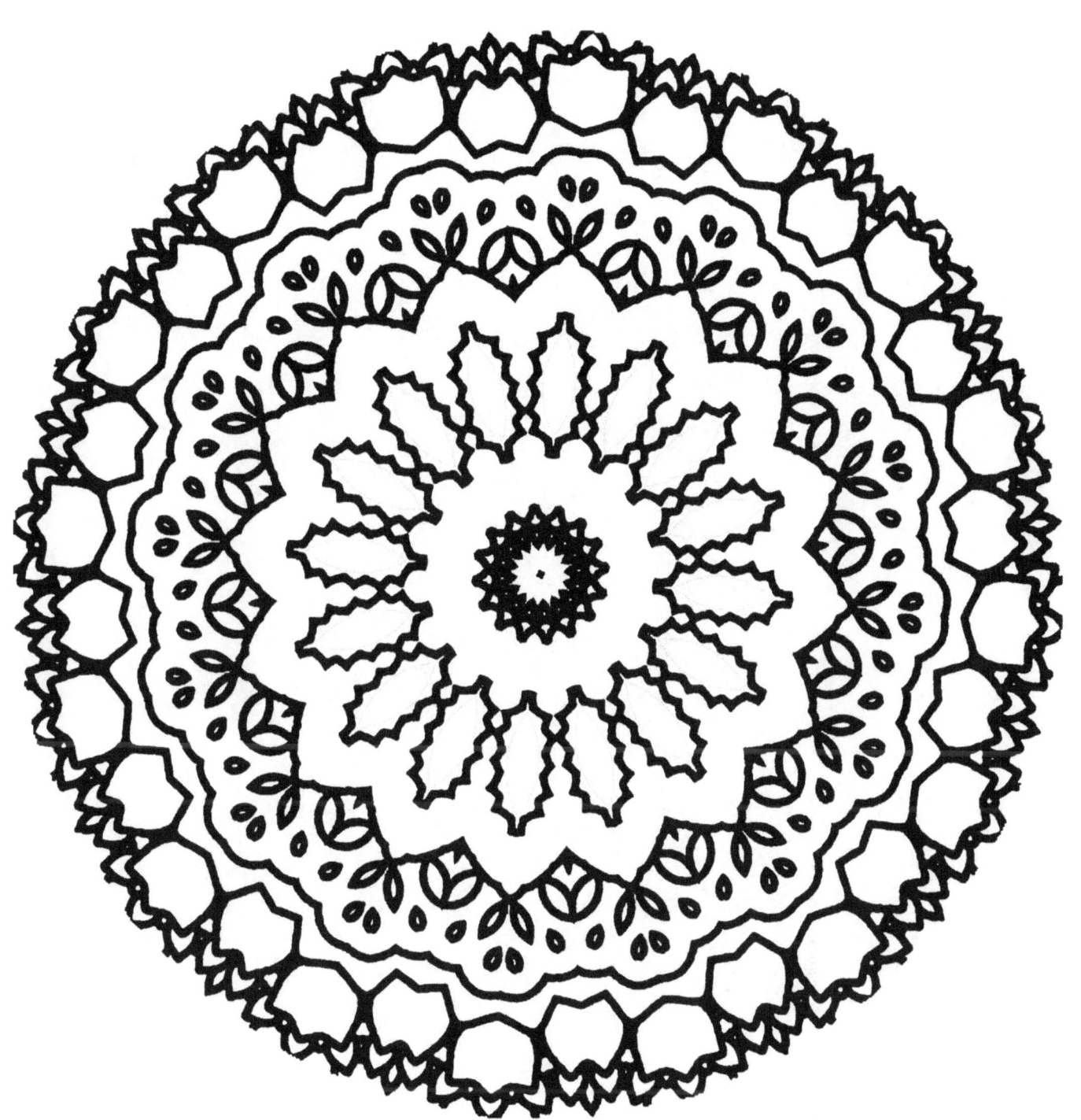

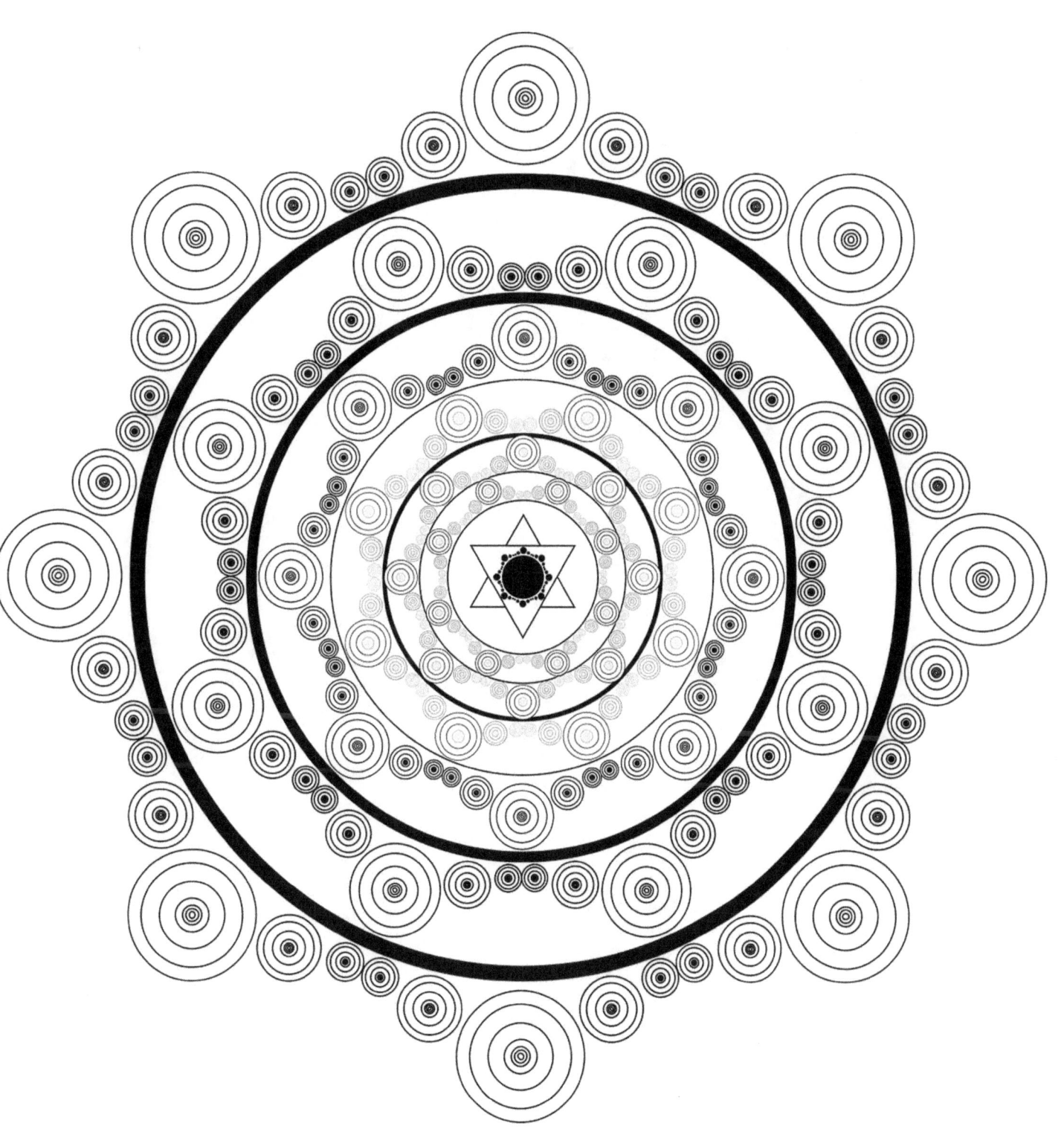

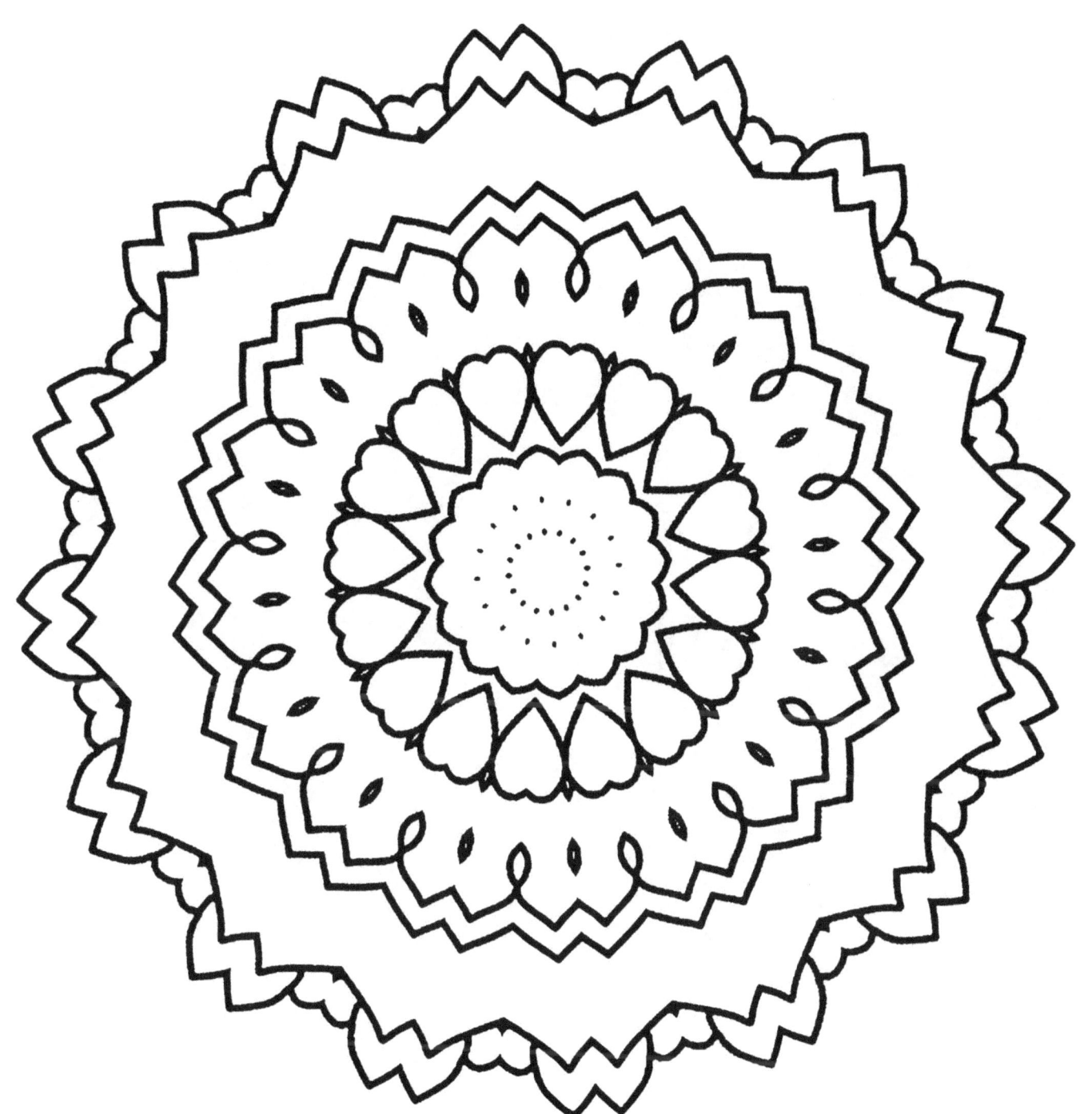

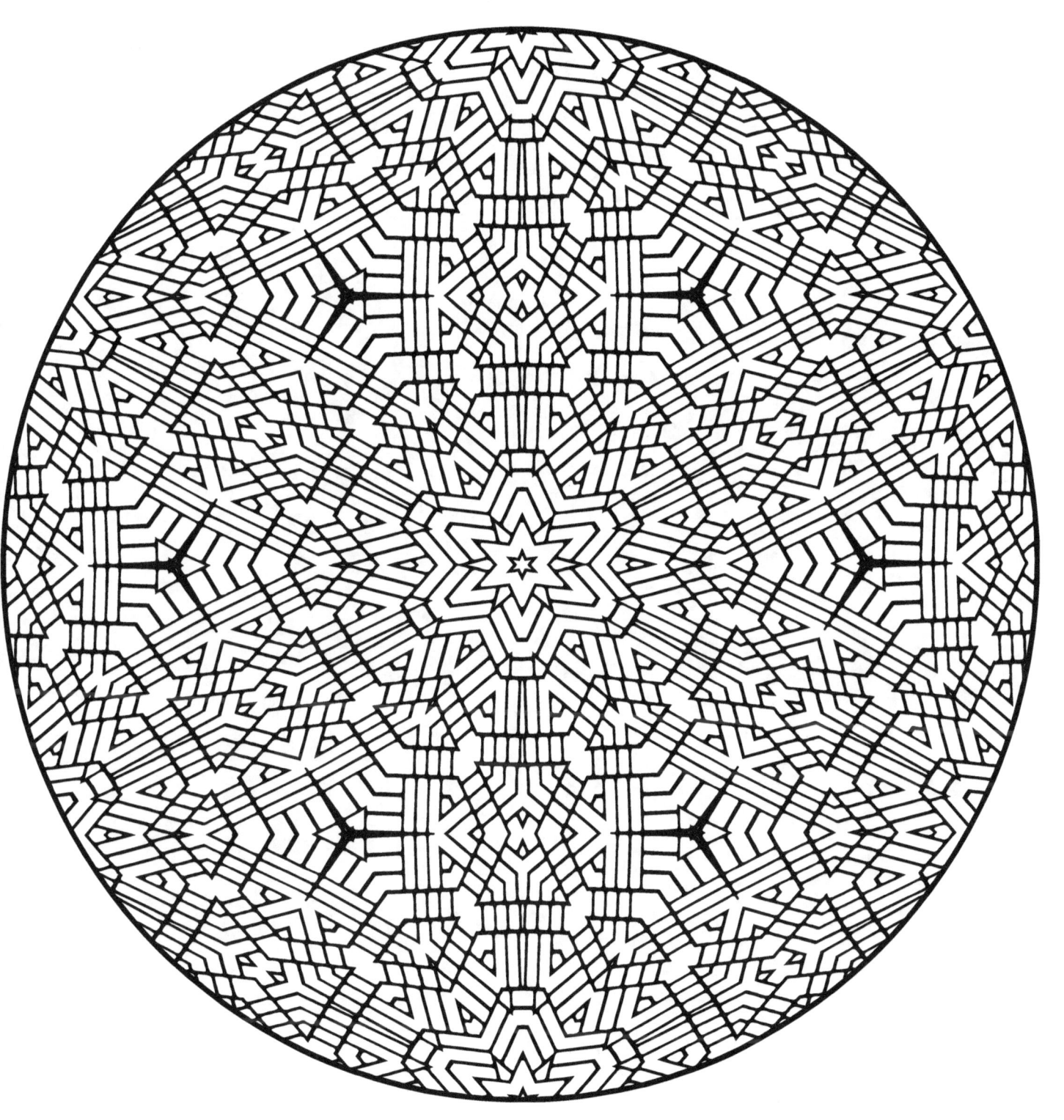

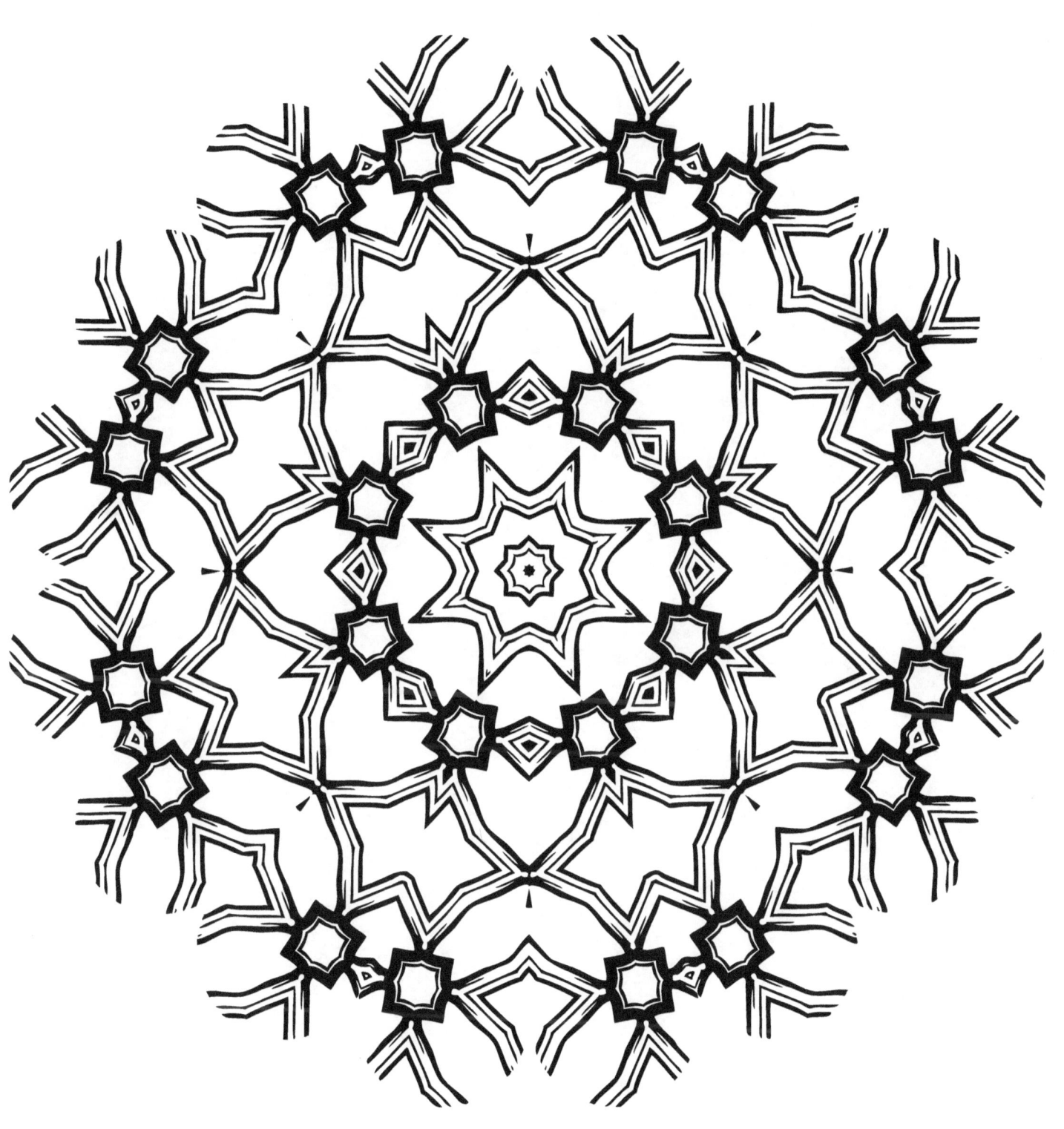

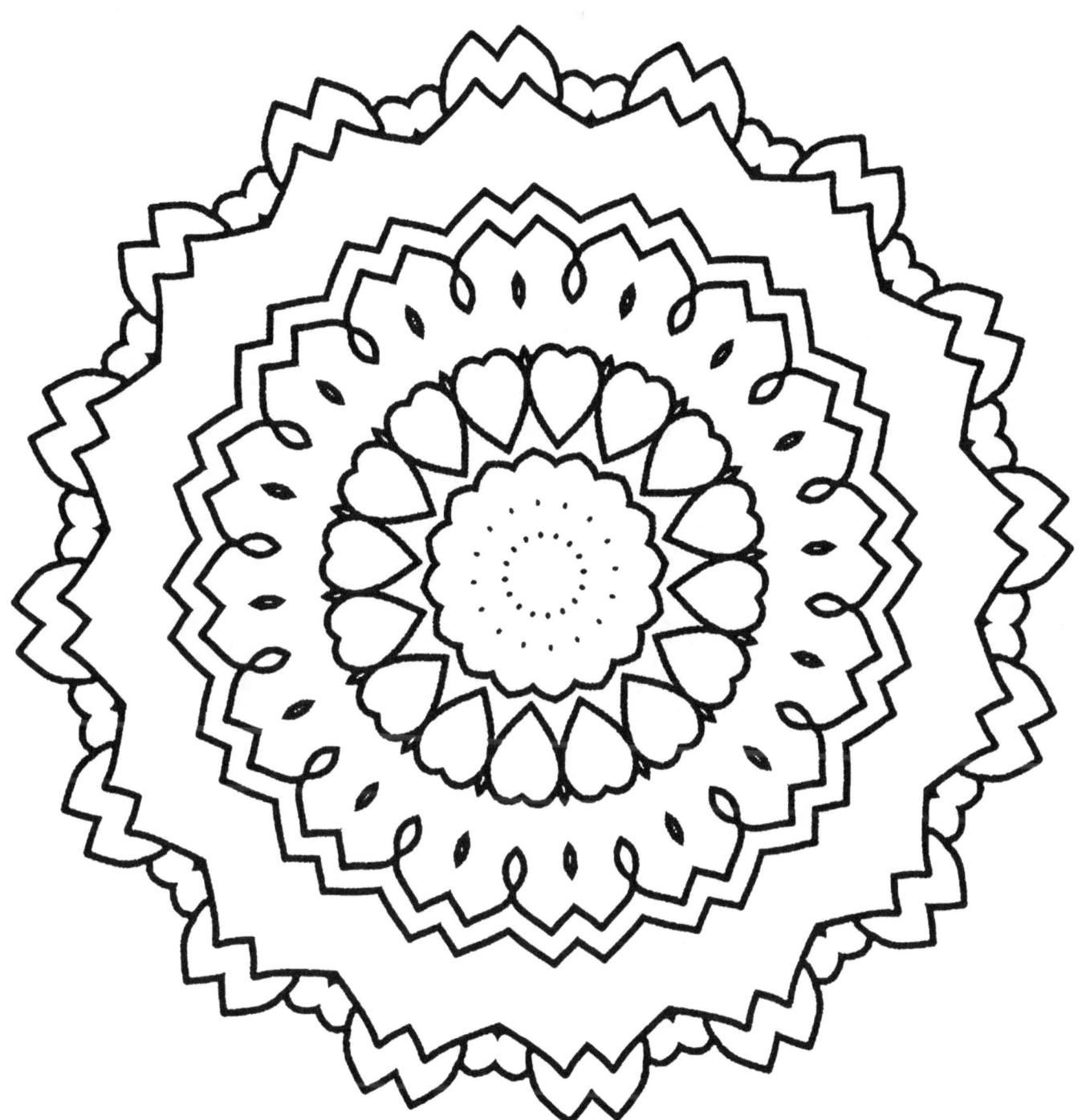

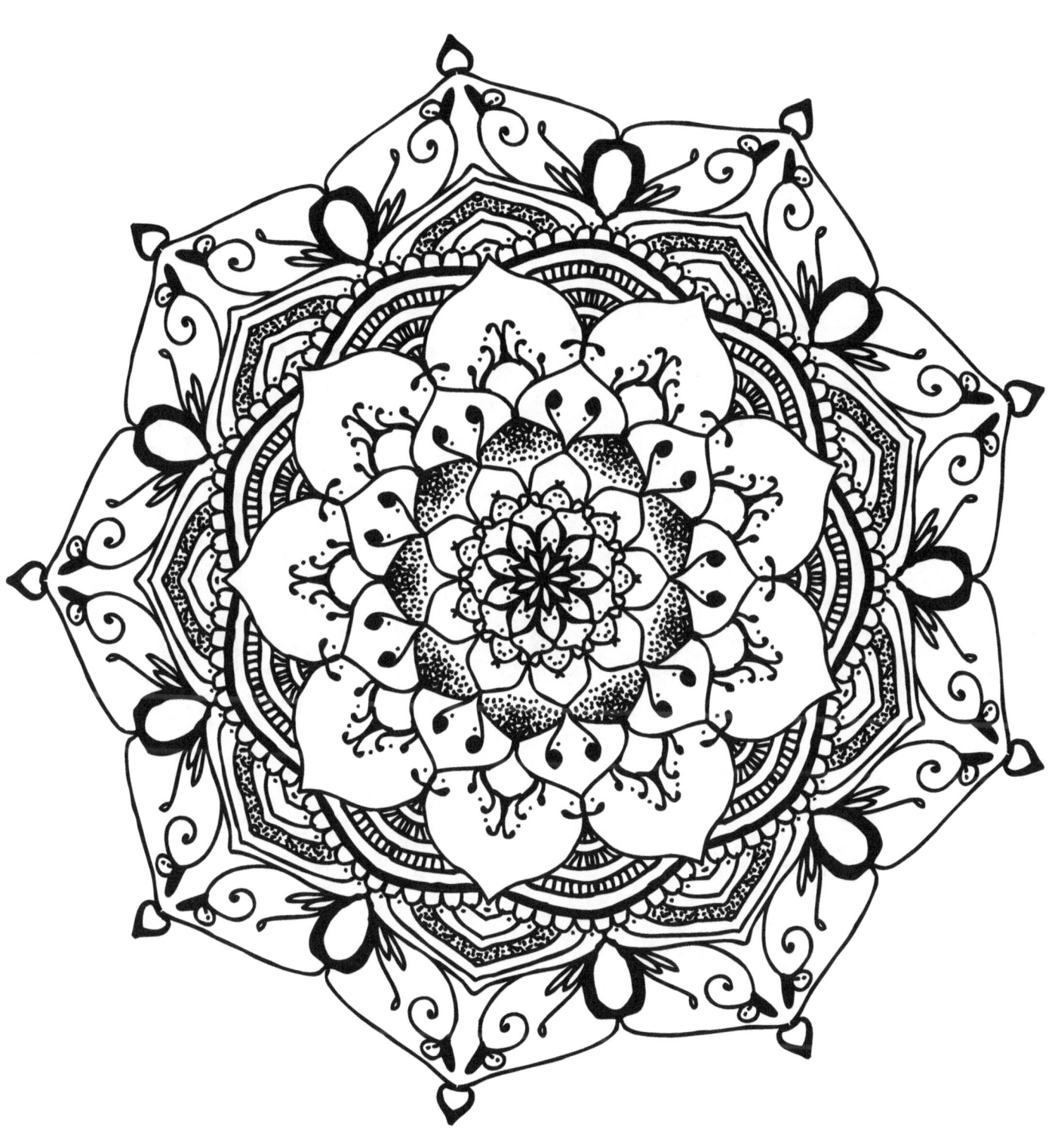

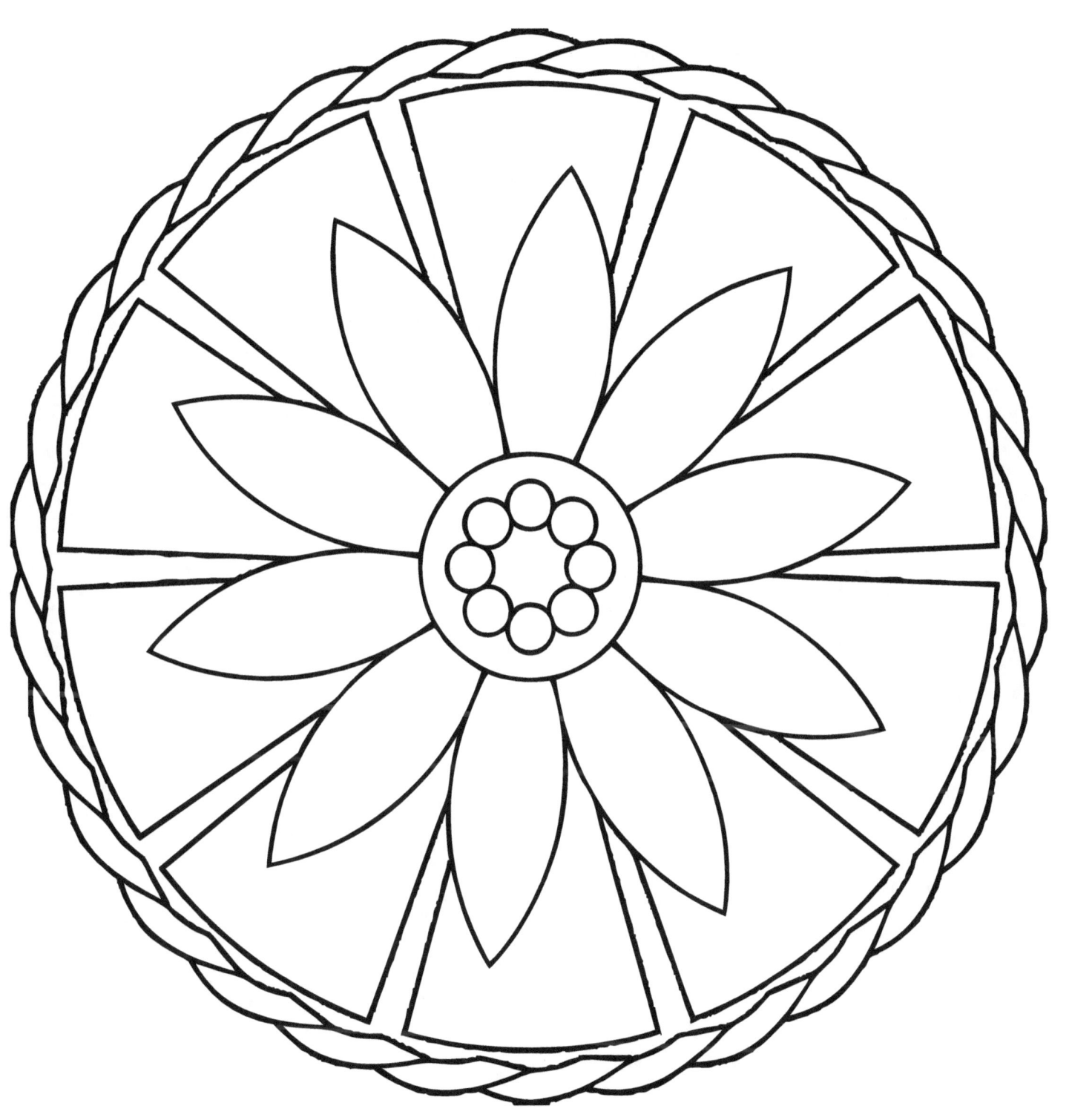

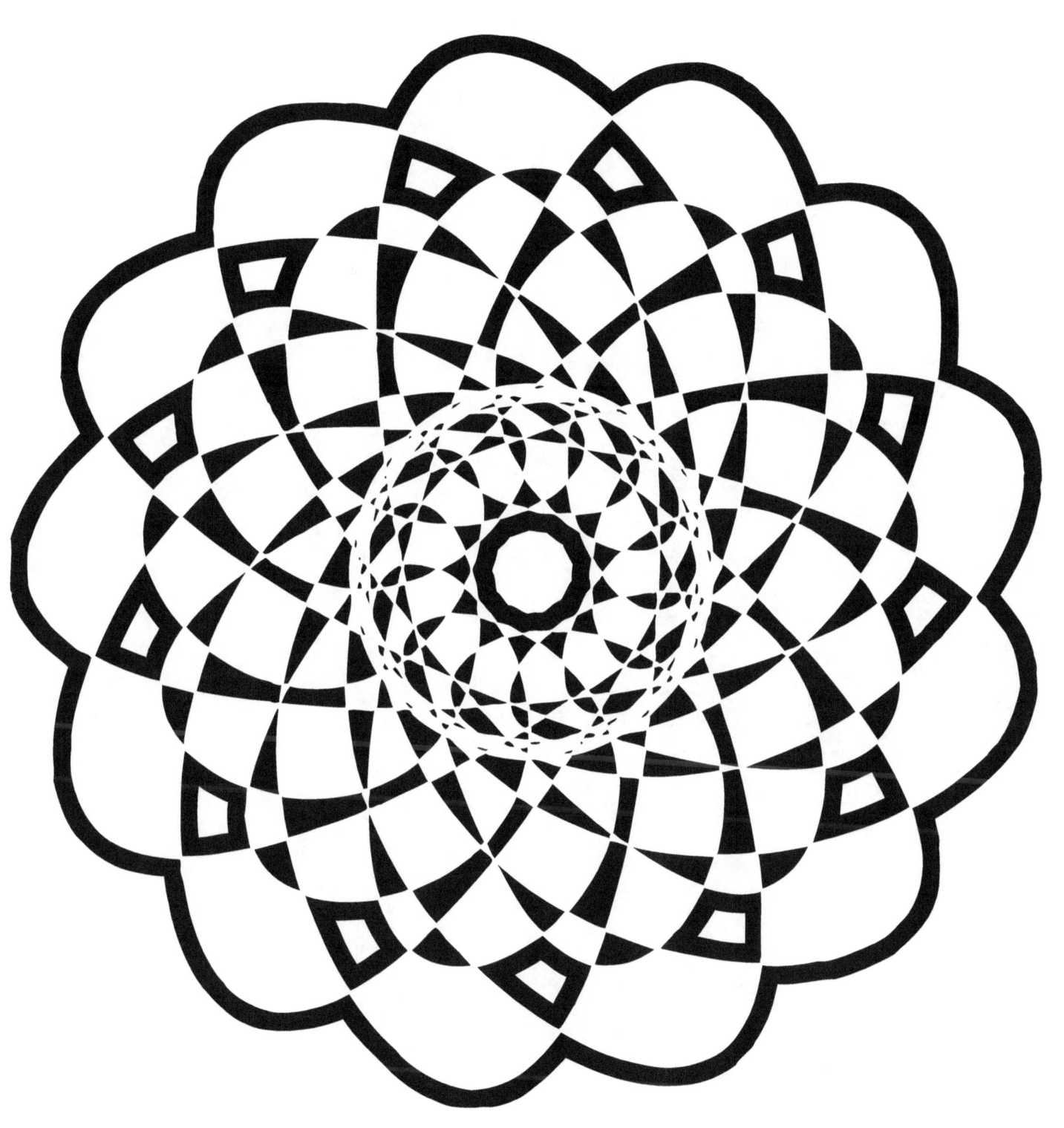

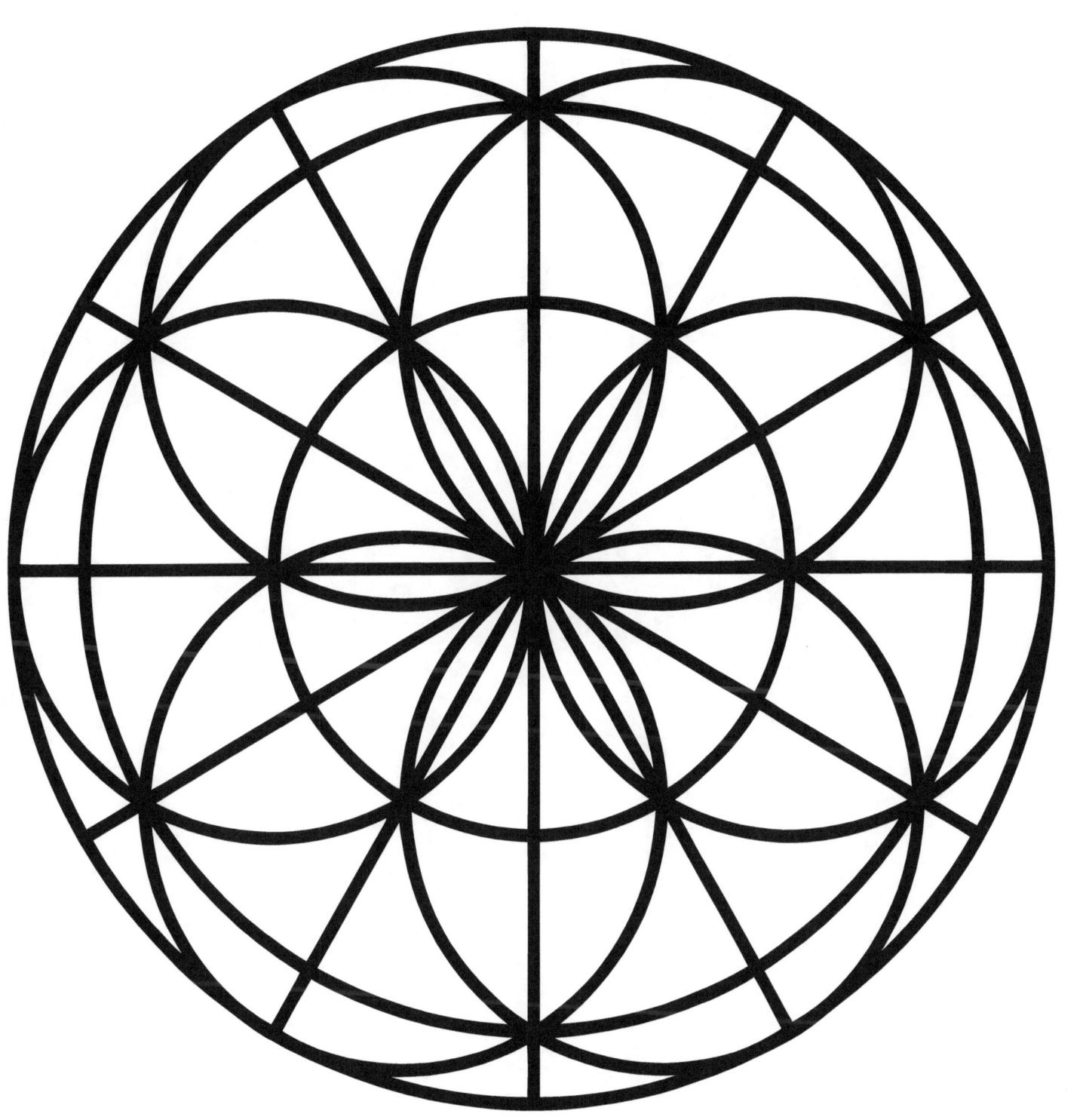

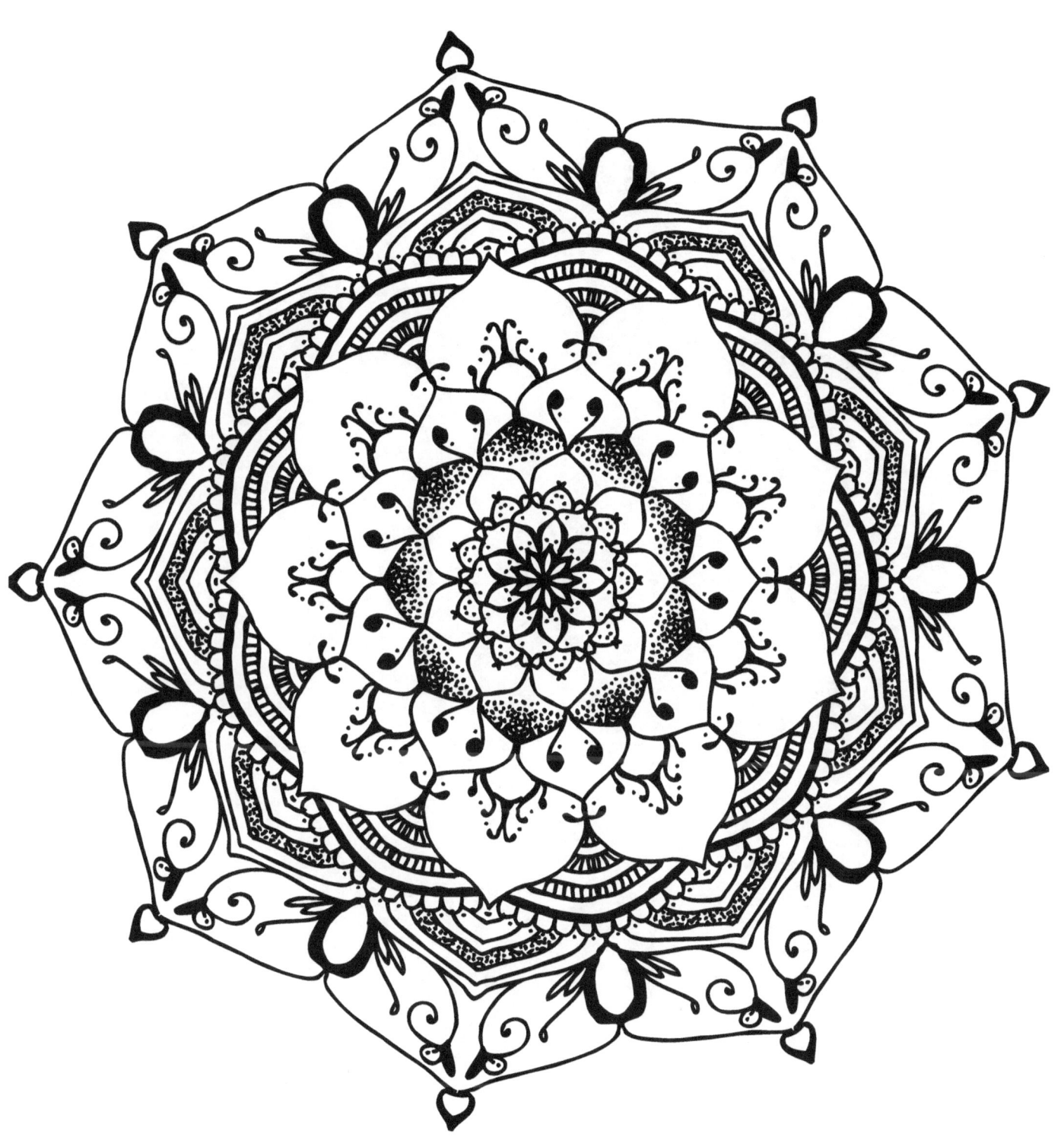

www.ingramcontent.com/pod-product-compliance
Lightning Source LLC
Chambersburg PA
CBHW080718190526
45169CB00006B/2426